DRAWING

FOR BEGINNERS

Simple Techniques for
Learning How to Draw

David Sanmiguel

STERLING

New York

Media, 4

con

Technique, 18

ents
Subjects, 68

Media

The wonderful thing about drawing is you don't need more than a pencil and piece of paper, although there are other types of media in additon to pencil that you can use to express yourself. In the following pages, we explore the most commonly used drawing tools, which are demonstrated throughout this book: graphite pencils, charcoal pencils, charcoal sticks, sanguine, nib pens, and more. We also include some suggestions about the kind of paper that is best to use for each drawing method, in order to achieve the best results.

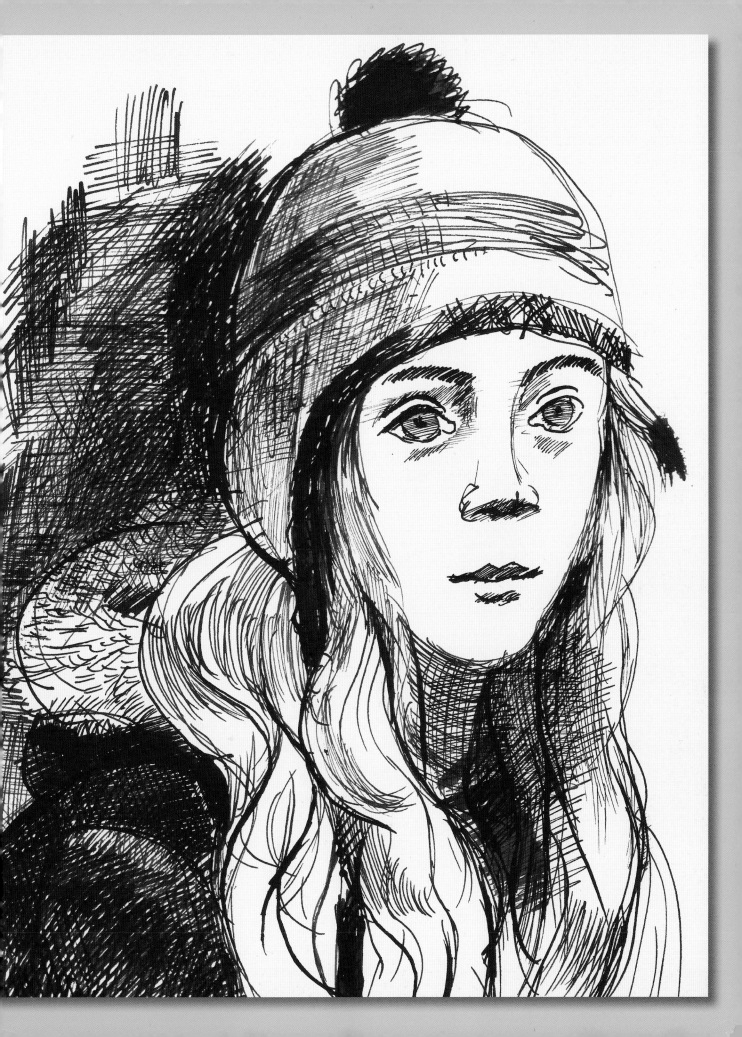

Graphite rods are sold either
encased in wood (pencils) or
inserted into mechanical pencils.
Rods of pure graphite are also
useful. All varieties are available
in different grades of hardness.

Pencil

A pencil is a basically a graphite
rod encased in a shaft of wood. It
is the most common medium used
for drawing. We all know that the
strokes made by a pencil are dark
gray and that the thickness of a
stroke depends on the sharpness
of the pencil point. Graphite can
leave a mark on almost any surface,
thus making it a universal medium.

Hardness
Pencil graphite is available in
different grades of hardness.
Strokes made with hard graphite
tend to be thinner and lighter;
however, artists who draw tend
to prefer soft pencils, which
have an intense, rich stroke.

The hardness of the point is
indicated by a number, a letter, or
a combination of both, printed on
the pencil. The letter may be an H
(for pencils with hard graphite) or
a B (for soft graphite). The higher
the number preceding the letter,
the greater the hardness/softness of
the graphite. Thus, a 6H pencil has
a very hard graphite rod, while a 6B
has a very soft graphite rod.

The most suitable pencils for
drawing range from 3B to 6B.
Various pencils of different grades
of hardness can be used in one
drawing (but no more than three),
in order to vary the intensity of
the strokes and shading, although
typically only one pencil is used.

Rods and
Mechanical Pencils
Many artists draw with soft
rods inserted into a mechanical
pencil, typically plastic, which
eliminates the need to constantly
sharpen the pencil. These rods
can vary in thickness, typically
ranging from 0.5 mm to 1
centimeter. The thickest ones
tend to be used to take notes
and create rough sketches on
large-sized pieces of paper.

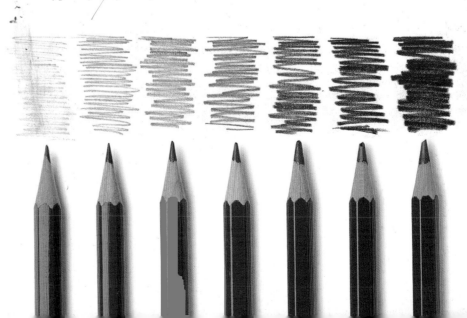

Pencils can be hard,
producing a very fine
or soft stroke, or soft,
producing an intense
stroke. The grade of
hardness is printed on
the pencil.

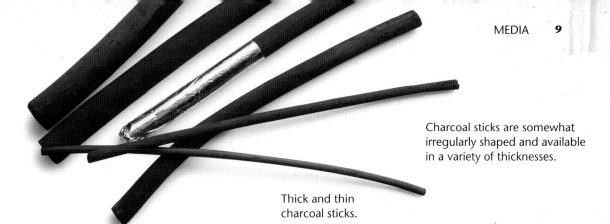

Charcoal sticks are somewhat irregularly shaped and available in a variety of thicknesses.

Thick and thin charcoal sticks.

Charcoal

Charcoal comes in thin sticks, sometimes called vine charcoal, or thick sticks of compressed charcoal. Thin or vine charcoal sticks are the media most often used for artistic drawing.

The sticks range in thickness from 2 or 3 mm, to up to 2 cm. An ideal size is one in the middle of this range. They are fragile and have a very dark gray (not black) tone. Strokes made by thin charcoal sticks are easy to erase and to spread across the paper with the aid of a cloth, or by blending them with one's fingertips.

Compressed Charcoal Sticks

Compressed charcoal sticks have a uniform thickness and an intense, black color. Their stroke is darker than that of thin charcoal sticks and leaves a more permanent mark, which is hard to erase.

They allow for drawing with uniform, solid strokes and are available in two or three different grades of hardness.

Charcoal Pencils

Charcoal pencils consist of a type of compressed charcoal rod combined with binding agents and covered by wooden casing. They are generally used in charcoal drawings and in studies to solve problems of light, shading, or volume.

There are varying gradations of charcoal pencils, particularly soft ones, which are very stable when mixed with clay. Pencils with charcoal rods combine the relative cleanliness of pencils with the intensity of strokes made by thin charcoal sticks.

They are used in small-sized drawings, as well as in larger drawings in order to highlight details and shading.

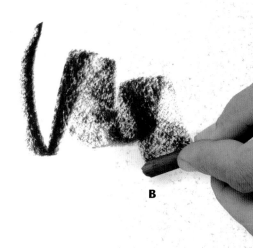

A

B

Charcoal sticks can be applied with a point in order to make precise strokes (A), or flattened, in order to make thick strokes (B).

Charcoal pencils make a blacker, deeper stroke than thick charcoal sticks.

Thin charcoal sticks provide variations in tone, based on the degree of blending and the pressure exerted on the medium.

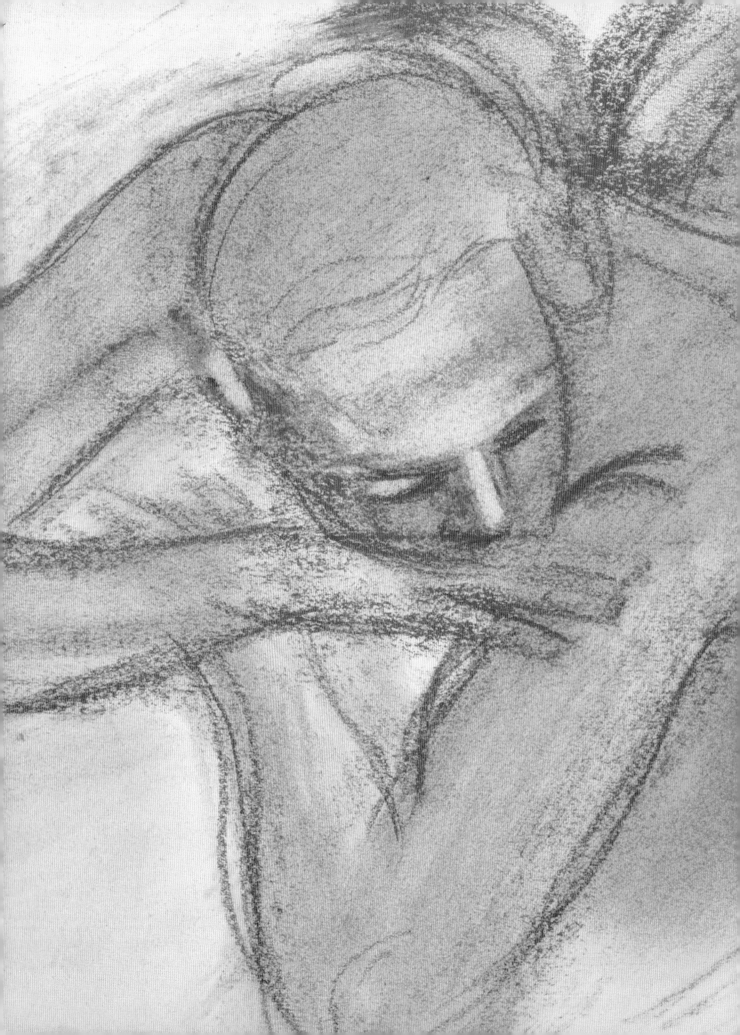

Sanguine

The term "sanguine" is used to describe rods of an orangish, brick-red color, traditionally used by artists as an alternative to the cool gray tones of charcoal sticks.

It is sold in sticks and pencils of different degrees of thickness, with a tonal scale that varies from dense, solid red-earth to pale pink, achieved by blending on paper.

Sanguine Crayons and Pencils

Sanguine crayons are round or rectangular, and their form is reminiscent of thick compressed charcoal sticks. Sanguine pencils are used to emphasize detail work and in small-sized drawings. The color of sanguine can vary, depending on the manufacturer,

Sanguine offers an interesting tonal scale, depending on the pressure exerted on the paper and the degree of blending.

although all of them make pencils ranging from a light, brownish-red to an earthy, red-orange color.

Sanguine pencils and crayons are drawing media that are orange-red in color. They can be used alone, or in combination with charcoal or chalk.

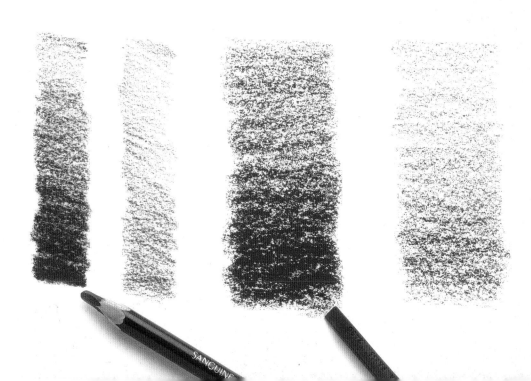

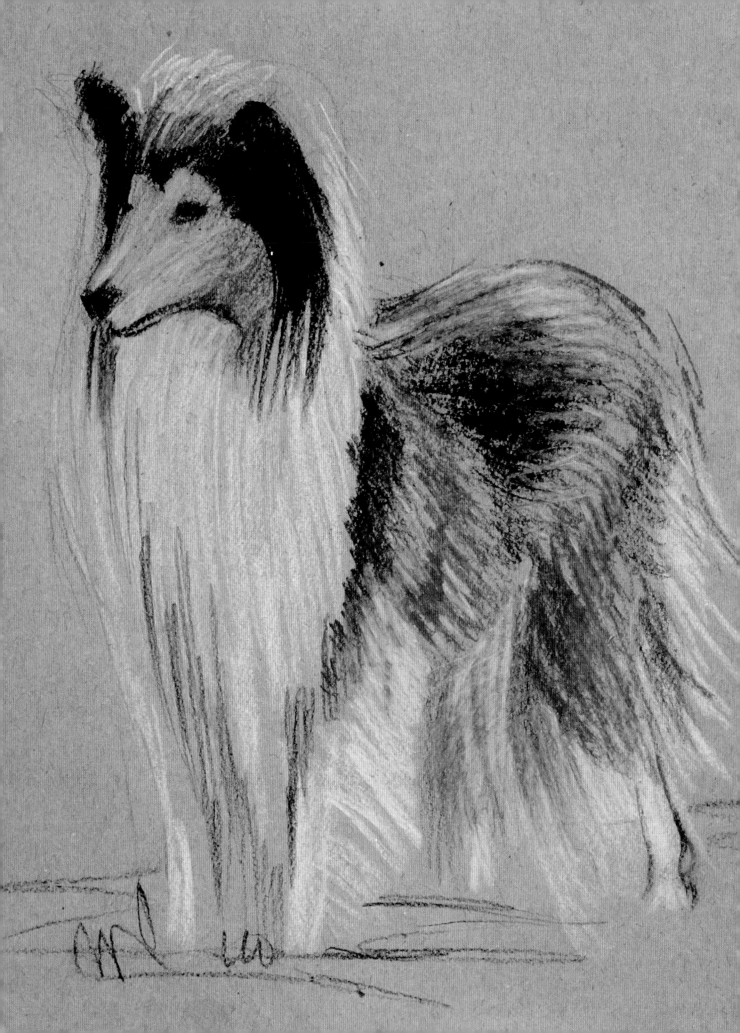

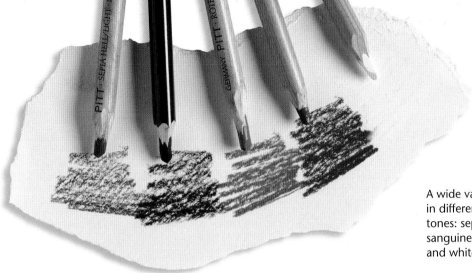

A wide variety of chalk in different harmonious tones: sepia, black, sanguine, grayish-brown, and white.

Chalk

These crayons and sticks come in sepia, grayish-brown, ocher, or white, and tend to be used with sanguine or charcoal pencils to achieve a richness in tone that black-and-white drawings cannot offer.

The most commonly available chalk has a rectangular shape, although it is also sold in pencil form.

Sepia-Colored Chalk

Sepia is a dark grayish-brown color, tending towards warm tones. The color of sepia chalk combines very well with the more fiery tone of sanguine, as well as with the black color of thin charcoal sticks. Sepia chalk allows for ample variation in tone and tends to be used on gray or light sienna-colored paper.

White, Gray, and Grayish-Brown Tones

White chalk is a very suitable complement when working with sanguine and thin charcoal sticks. Because it is white, white chalk must be applied to colored paper for it to be effective. There are also gray and warm grayish-brown chalk varieties, thus increasing the range of possibilities for creating colored drawings.

Three-Color Drawing

This is a traditional type of drawing using charcoal and sanguine. It consists of using charcoal sticks or pencils, sanguine, and white chalk together. Each of the tones develops an area in the spectrum of tones in the drawing. To develop this technique, ocher, sienna, grayish-brown, or gray colored paper is used, so that the white-colored chalk becomes highly visible.

Chalk sticks and pencils are used to best effect on soft-colored paper with warm or cool tones.

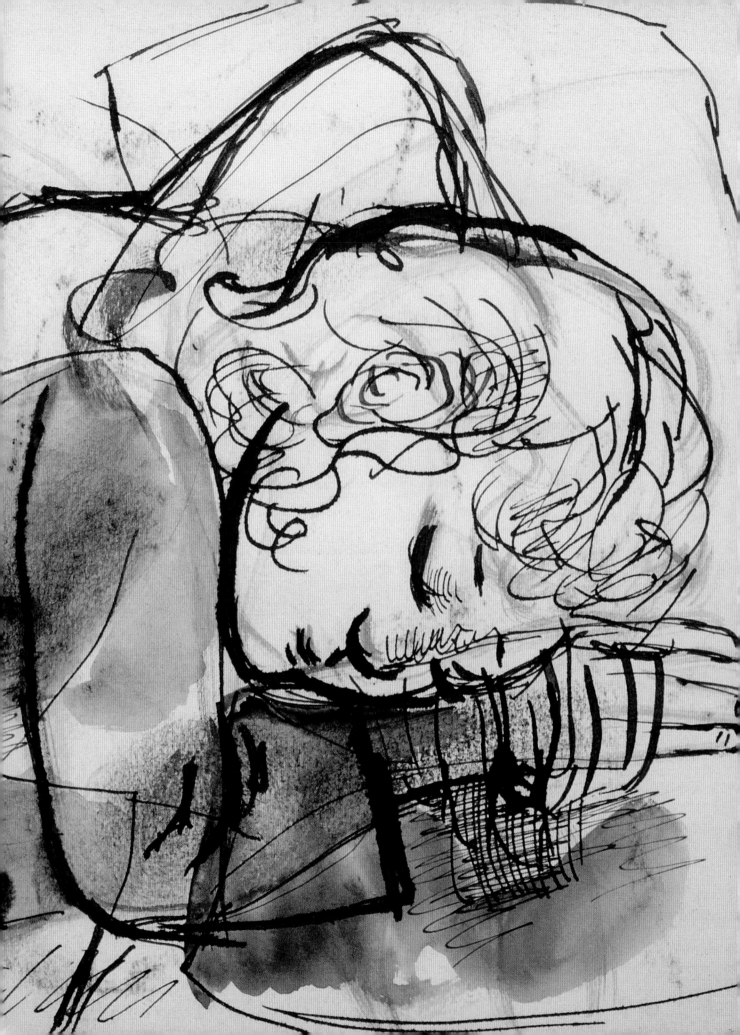

Ink washes can be made with India ink (always black) or sepia ink. Both can be thinned with water.

Ink

India ink is dense, opaque, and very resistant to light and the passage of time. It can be thinned when mixed with a small amount of water; after it has dried, it becomes insoluble. It comes in small jars and bottles of varying sizes. Traditionally, India ink consisted of an ink stick that had to be moistened and rubbed against a stone with a slightly rough surface (ink stone), in order to acquire the appropriate continuity and consistency. Ink stones are used with a paintbrush in a technique known as sumi-e (Japanese ink-wash painting). Whatever tool is used, the surface for drawing with ink is always paper.

Colored Inks

Ink is currently manufactured in a wide array of colors. They are quite transparent and available in bright, intense shades.

They have the drawback, however, of being unable to resist the effects of light, and fade after a short period of time.

Manufacturers rely on protective aerosol sprays to slow down the fading of drawings made with these inks.

Quill Pens and Brushes

Long ago, quill pens were the universal instrument for drawing and writing in ink.

Nowadays, very few artists use them, preferring metal nib pens or modern instruments for writing and labeling instead. However, there are still those who prefer using the traditional quill pen in order to achieve more rustic, "picturesque" results.

Also commomly used with ink is the paintbrush, whether of a conventional type or the Chinese or Japanese variety.

Nib Pens

A nib for drawing is a metal component, smaller and more flexible than a writing pen, which is inserted into a wooden or plastic pen holder. Its point has an incision or cut in the form of a small channel, in which the ink accumulates and then descends towards the tip while you draw.

A fine, felt-tip pen can be substituted for a nib pen for impromptu work or work done outdoors.

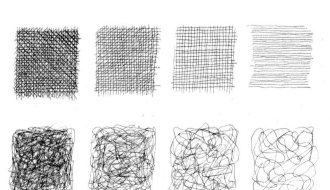

Several examples of crosshatching (see pages 52–53) done with nib pens to achieve relatively dark blocks of shading.

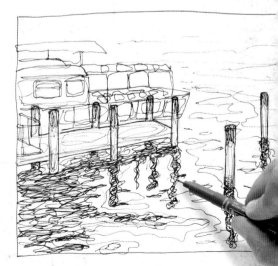

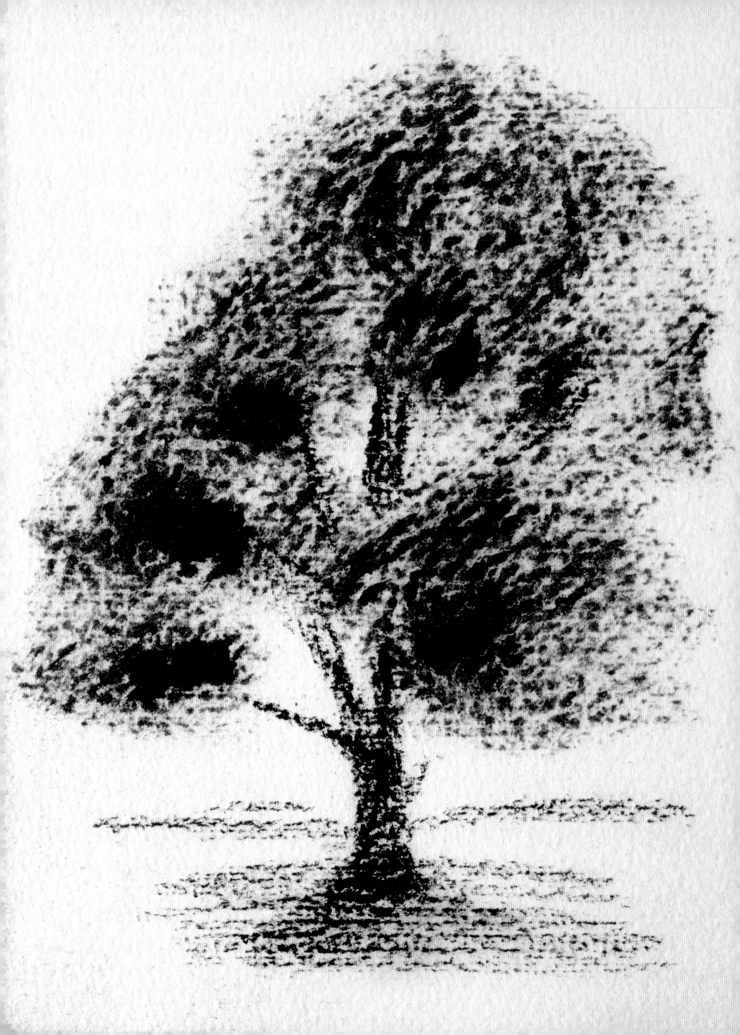

Paper

Drawing paper can have a grain (texture) or be glossy (smooth), and is available in white, cream, or color stock.

Paper with a grain is best for graphite pencil, chalk, pastel, sanguine, or thin charcoal sticks; smooth is best for drawing in pen, although it is also suitable for drawing in shades of gray of varying intensity with graphite pencil. Both varieties offer many intermediate qualities and textures depending on the raw materials and the finish used, as well as its weight (in grams) per square meter.

Paper for Drawing in Pencil

Fine or smooth-grained paper allows for softened shades of gray of varying intensity and a "velvety" quality, for which reason it is recommended for drawings using soft graphite pencil and colored pencil.

Paper for Charcoal, Sanguine, and Chalk

Medium-grain paper is recommended for dry media such as charcoal, sanguine, chalk, or pastel. Laid paper, which has a highly visible, ribbed texture, is also excellent for dry media. Canson paper is the most commonly used due to its versatility, as it offers a thick grain on one side and a medium grain on the other.

Watercolor paper, although it is specially made to allow for wet materials because of its rough-grain texture and heavy weight, can also be interesting to use with certain techniques for drawing with thin charcoal sticks.

Paper for Ink Drawings

Paper for drawing in pen must be smooth, without any grain, and not very absorbent. With any other type of paper, the sharp point of the nib could dig in, get stuck, or not be able to glide easily. Additionally, the paper must possess a certain degree of firmness in order to support the pressure of the strokes and offer a resistant, completely smooth base. Any glossy paper is appropriate for drawing with nib pens.

Storing Paper

Paper is susceptible to changes in temperature and humidity, which is why it is best to store it horizontally in a cabinet with wide drawers or in folders larger than the size of the paper. It should never be kept folded up or rolled, as this causes it to warp and the fibers to lose their original position. Ensure that the paper is dry before storing, in order to avoid humidity stains.

For drawing with a graphite pencil or colored pencils, smooth paper with a very fine grain is best.

Medium-grain paper is ideal for dry media such as charcoal, chalk, and sanguine; note that the texture of the paper is visible in the image below.

Technique

The technique of drawing requires learning specific skills, which may be achieved in many ways. In this book, we make use of very simple and effective methods to draw with lines and shading.

The first section begins with basic structures: line drawings with only essential outlines. From there, we continue to enhance the drawing with highlights and shadows by employing shading, varying degrees of intensity, and many other key aspects.

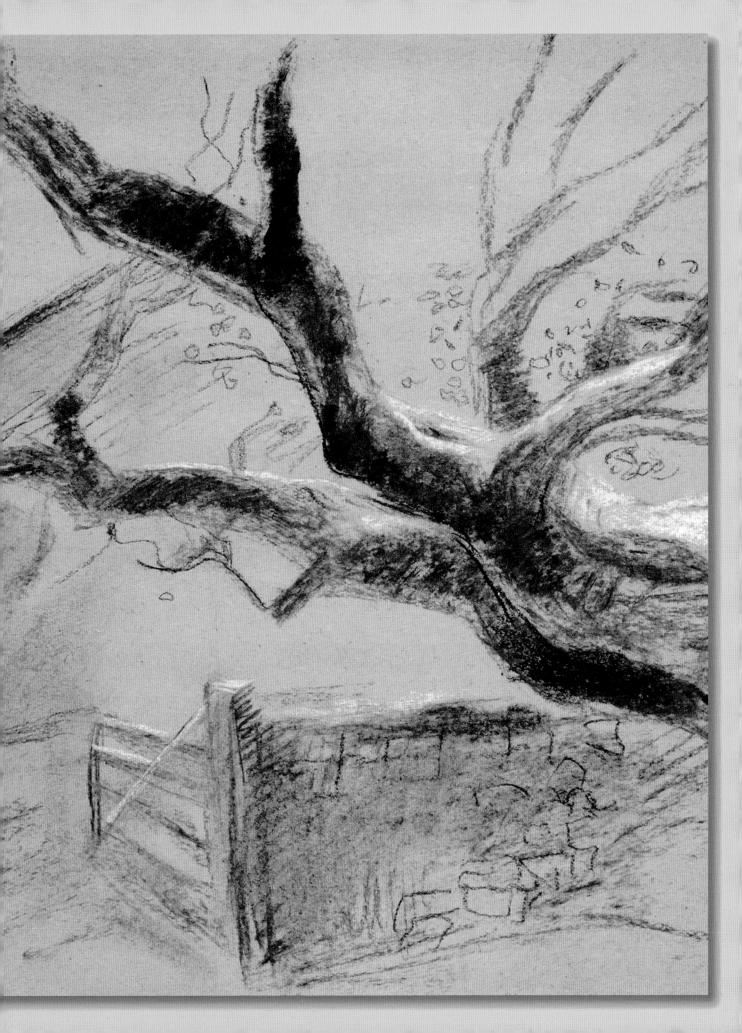

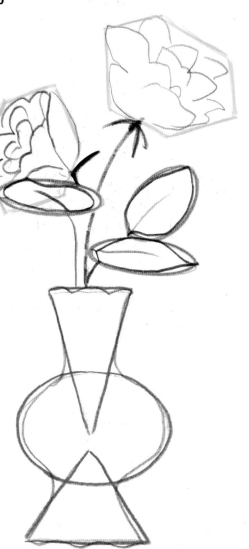

We perceive real objects by noting their details and appearance (shadows and highlights, shape or contour depending on one's perspective, texture, color). When starting a drawing, not everything you see can, or should, be represented simultaneously. Start by identifying the basic shapes—a glass is a cylinder, a silhouette of an apple has a somewhat flattened circumference, a lemon is an ellipse, and so on. The simpler the structure, the easier the object is to recognize and draw.

Drawing patterns

The vase above is made up of two triangles and an oval. Other ovals fit together to make the leaves, and two trapezoids resemble the shape of flowers. Representing real objects in drawing starts by identifying a subject's inherent structure and shape.

Everything you see can be reduced to basic geometric shapes. These basic shapes are easy to draw: one must only pay attention to size and symmetry, as geometric shapes tend be symmetrical.

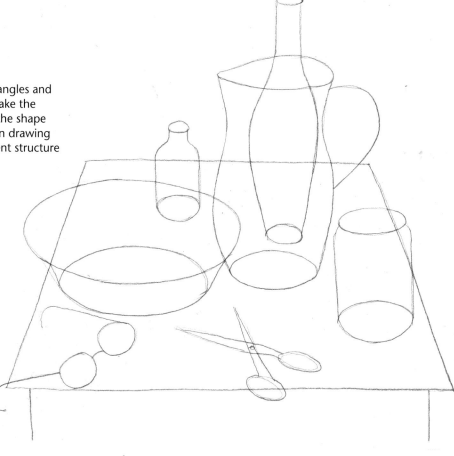

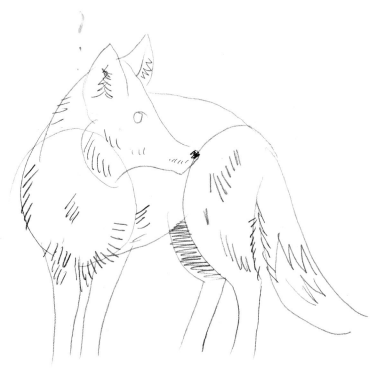

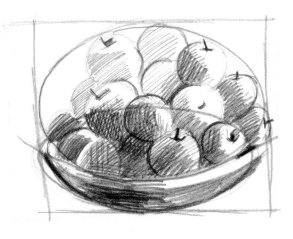

These apples have been outlined using two ovals that cover the pieces of fruit and the bowl, respectively.

This fox is drawn with ovals and the arcs of a circle. It is a matter of adjusting the size and dimensions of the basic strokes. Once this is done, the drawing of the animal emerges almost by itself.

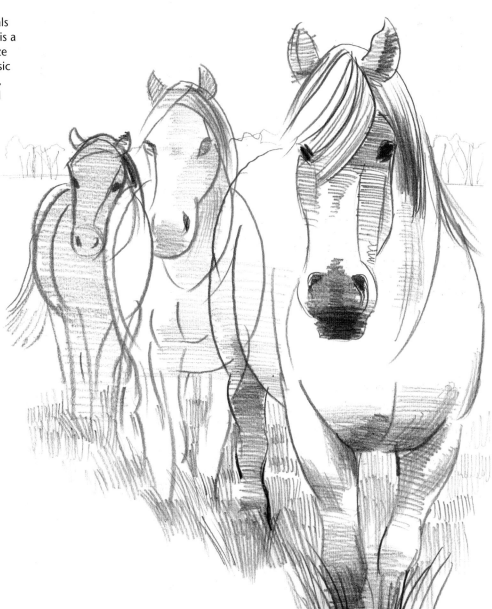

There is no subject that cannot be reduced to its fundamental shape and structure.

Once you learn to see the structure within a subject, it only takes a little bit of practice to achieve good results in your drawing.

Basic outline

This first exercise shows how to build the shape of a sheep, starting with ovals and simple straight lines. We start by determining the proper size for each shape. The result is very schematic but it allows the drawing as a whole to be checked to see that it is correct at every stage in the process. You should draw quickly and intuitively.

The below basic shapes are the building blocks for a drawing of a sheep.

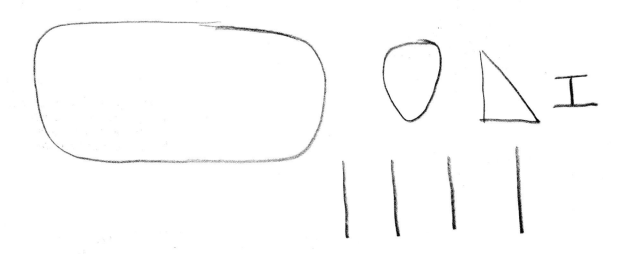

1 The rounded rectangle nicely forms the body of the sheep. The head is formed by the oval, while the legs, neck, and ears are made up of short straight lines.

We recommend
soft graphite pencil for an intense and clearly visible stroke; this will allow you to sketch quickly without pressing the point of the pencil on the paper.

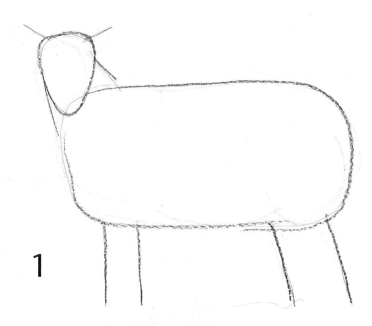

1

2 We round out the structure of the subject through simple arcs, moving from initial stiffness to more natural contours.

3 We thicken the legs, flesh out the ears, and draw two simplified eyes on each side of the head. This is how easy it is to depict a sheep!

2

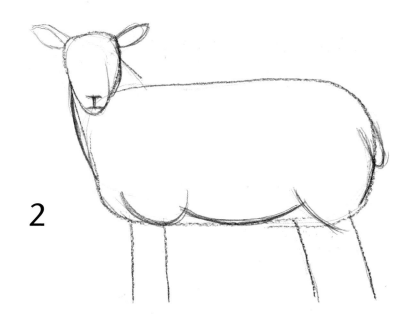

3

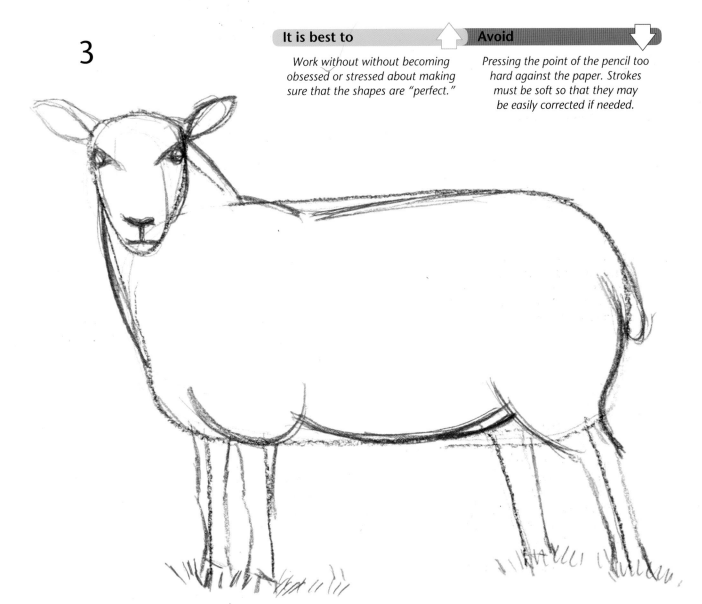

It is best to	Avoid
Work without without becoming obsessed or stressed about making sure that the shapes are "perfect."	*Pressing the point of the pencil too hard against the paper. Strokes must be soft so that they may be easily corrected if needed.*

Important details

Basic shapes are good to master not only for drawing the general contours of subjects but also for depicting their internal details. It is all about using a figure that best fits the shape of the detail. In this cat's head, we attempt to recreate the animal's features using simple straight and curved segments. The shape of the head makes use of a basic symmetrical figure in which the ears stand out. These general figures need to be well proportioned to each other.

In this drawing, we again use extremely simple shapes to depict both external contours and internal details.

1

1 We first draw a bowl-shaped outline, with a straight upper line on top, which serves as the contour of the head.

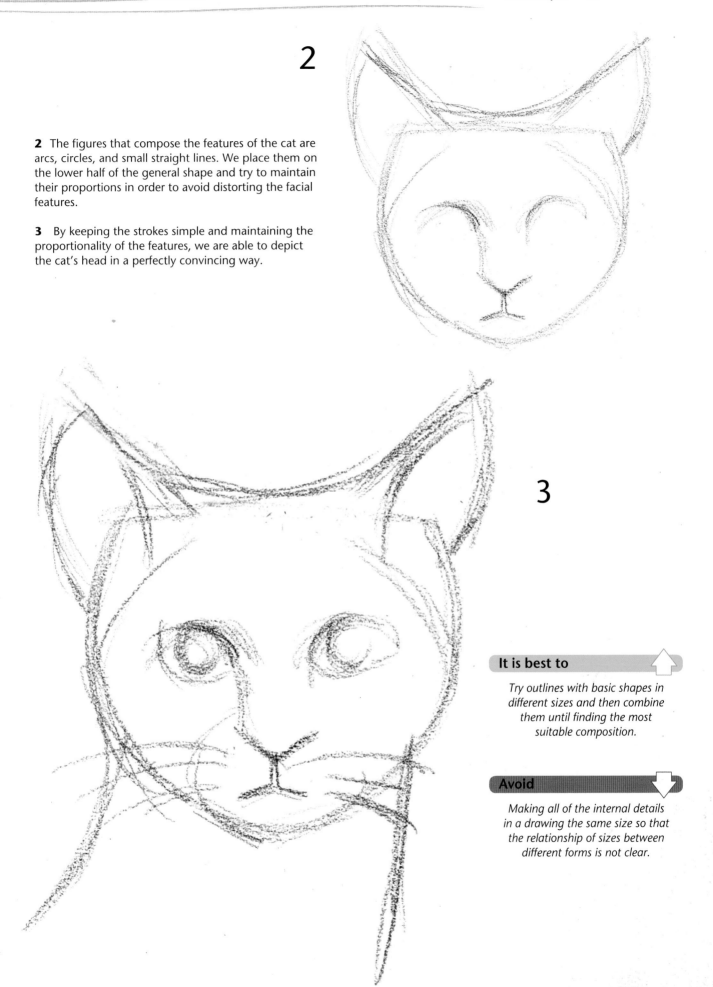

2

2 The figures that compose the features of the cat are arcs, circles, and small straight lines. We place them on the lower half of the general shape and try to maintain their proportions in order to avoid distorting the facial features.

3 By keeping the strokes simple and maintaining the proportionality of the features, we are able to depict the cat's head in a perfectly convincing way.

3

It is best to

Try outlines with basic shapes in different sizes and then combine them until finding the most suitable composition.

Avoid

Making all of the internal details in a drawing the same size so that the relationship of sizes between different forms is not clear.

Basic shapes and contours

With practice and repitition, you will learn
to subtly contour as you draw the the basic
geometrical shapes so that your initial outlines
look more natural and flowing. We revisit the
sheep here, as well as a dog and cat, to illustrate
how the outline of a shape can gradually become
more realistic. Follow the step-by-step drawings
here and by the end of the exercise compare your
drawings to the original sheep drawing you did
and see if your line has become more fluid.

1 This initial sketch is not as stiff as the
ones on previous pages and, in some
areas, suggests the real contours of the
subject.

2 Let's sketch the features of a face by
making very simple strokes inside the
general oval of the head.

1

2

3 Add the lines of
detail shown here;
keep in mind that the
forms shown are based
on simple geometric
shapes.

3

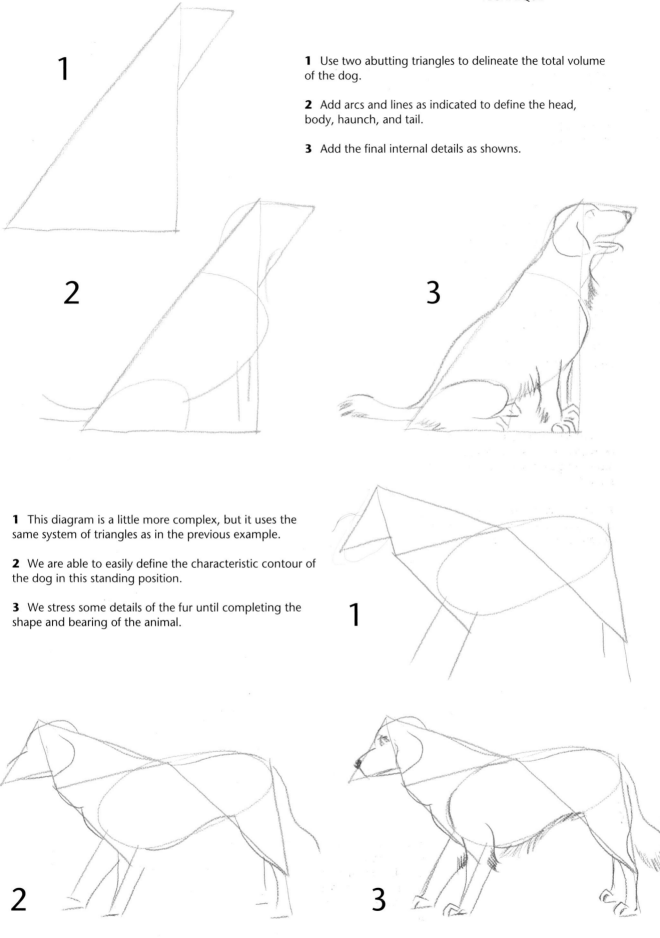

1 Use two abutting triangles to delineate the total volume of the dog.

2 Add arcs and lines as indicated to define the head, body, haunch, and tail.

3 Add the final internal details as showns.

1 This diagram is a little more complex, but it uses the same system of triangles as in the previous example.

2 We are able to easily define the characteristic contour of the dog in this standing position.

3 We stress some details of the fur until completing the shape and bearing of the animal.

1

Once you have developed the basic structure of your drawing with sufficient skill, you can make improvements to it: you can apply crosshatched highlights or shadows, small smudges to indicate texture and surface, and shading, all of which adds character and vitality to the plain contours. This sequence proposes the use of some simple and effective highlights in significant areas of a drawing.

1 The basic outline consists of three ovals of different size and position. They show the schematic form of the head, chest, and trunk of the dog. We add straight segments to show the placement of the legs.

Outlining with highlights

2 We define contours in those areas where the oval does not fully articulate the shape (legs, tail, ears, and face). If shapes are well proportioned, these new lines will sit in a natural-looking looking way within the preliminary ovals.

3 We finesse the basic shapes by adapting the contours to the actual profile of the animal, but without adding new details.

2

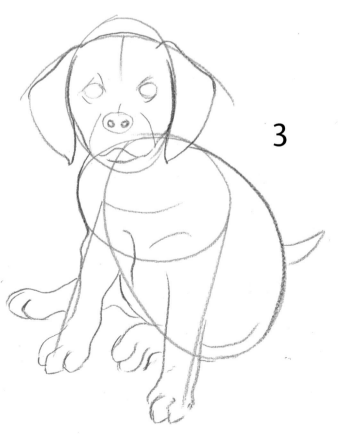

3

4 With a pencil, we draw diagonal hatchmarks in those areas that should be accentuated: tips of the ears, eyes, snout, tail, and the belly. Draw the hatchmarks softly at first and then choose the area you want to further emphasize and add crosshatches (see pages 52–53); on the dog we emphasized his head.

It is best to

Draw accentuating hatchmarks softly at first; then, in the area you want to feature most prominently, crosshatch in the opposite direction to accentuate the darkness in tone.

Avoid

Systematically highlighting every area in the drawing. In a figure, the head and face are usually the most important parts.

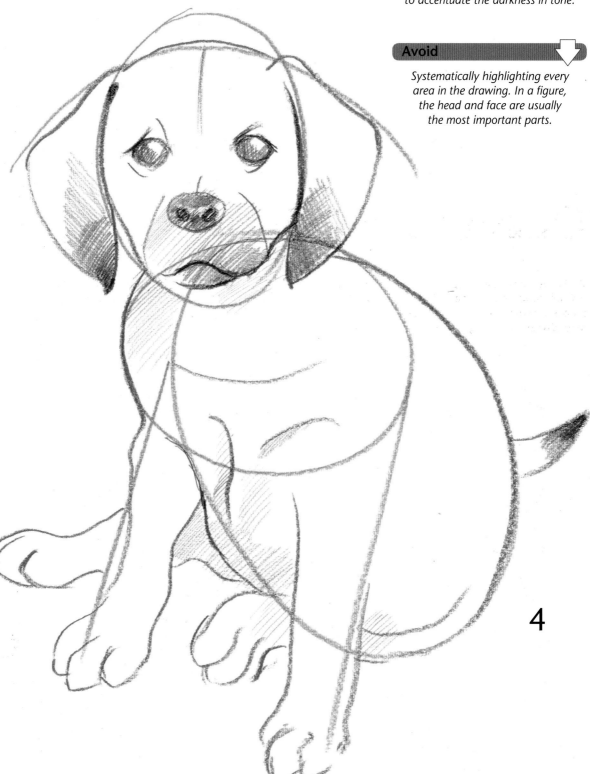

4

Shading and texture

Stressing or emphasizing certain characteristics of a subject helps to give it character as well as volume in space. Normally, volume is indicated by adding crosshatching or soft shading along the sides of the shape, but we can also take advantage of other aspects of appearance: decoration, shine, texture, fur or hair, pattern. Here a few alternative methods are shown in pen and pencil.

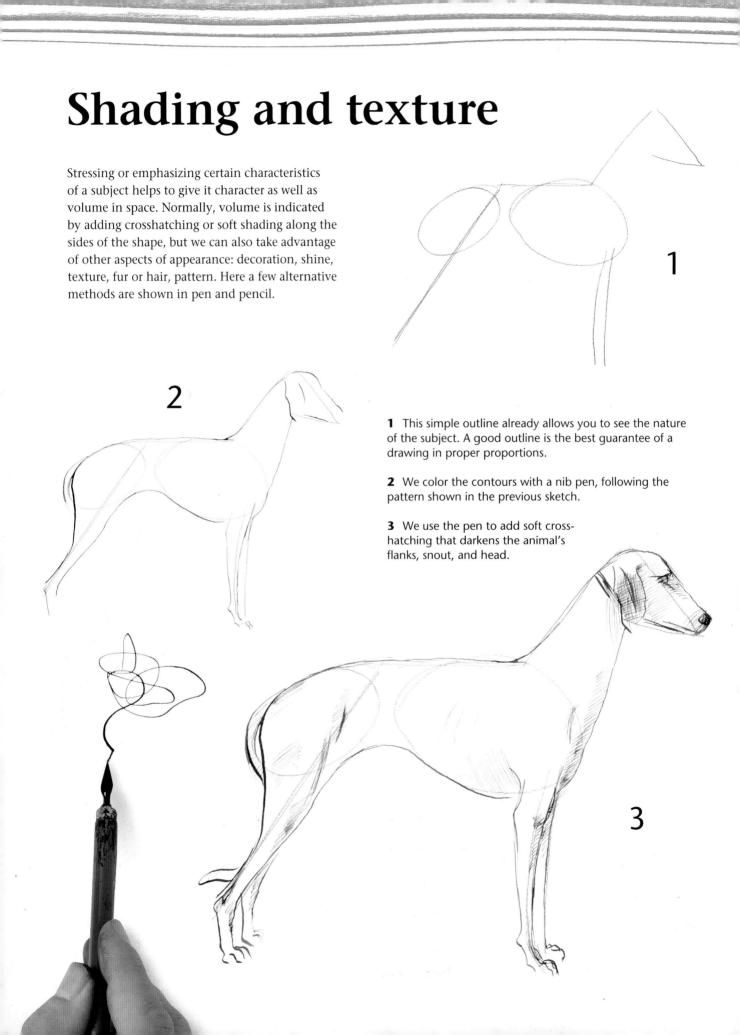

1 This simple outline already allows you to see the nature of the subject. A good outline is the best guarantee of a drawing in proper proportions.

2 We color the contours with a nib pen, following the pattern shown in the previous sketch.

3 We use the pen to add soft cross-hatching that darkens the animal's flanks, snout, and head.

1

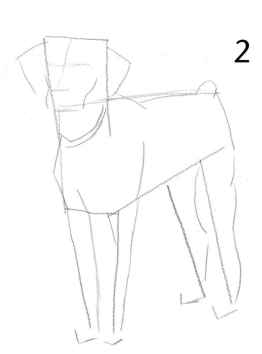

2

1 This sketch is based on blocks that are more or less rectangular, under which we draw the straight lines of the animal's legs.

2 We try to come as close as possible to its real contours by using fairly straight strokes that reconstruct the lines of the boxed figure.

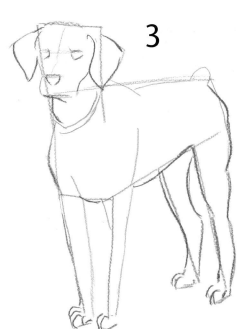

3

3 Once we smooth out the previous strokes, we easily get the final contour of the dog.

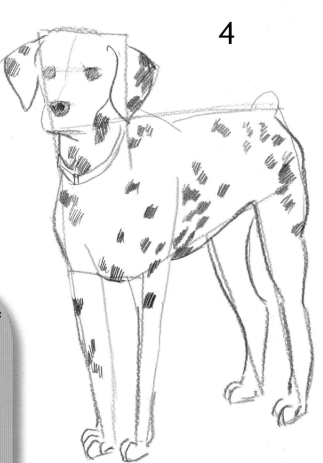

4

4 To create the appearance of fur and to indicate that it is a dalmatian, we add spots drawn in pencil in different areas. In this way, we can create a slight suggestion of volume.

I suggest using different colored pencils for the basic outline, the contours, and the highlights; in this way, you will know where you got it right and where you might need to make any adjustments.

Outlining with charcoal sticks

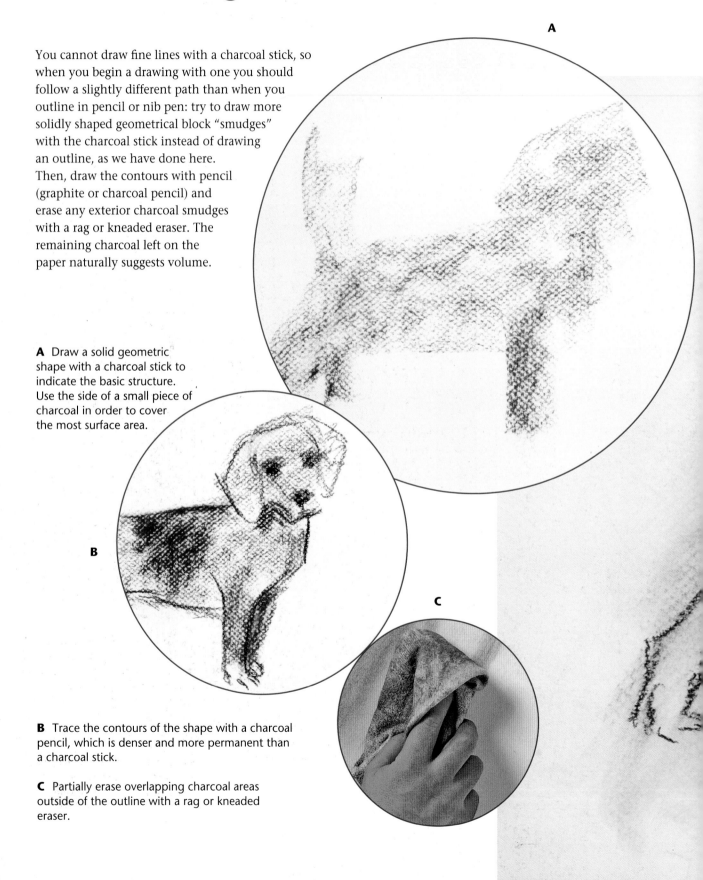

You cannot draw fine lines with a charcoal stick, so when you begin a drawing with one you should follow a slightly different path than when you outline in pencil or nib pen: try to draw more solidly shaped geometrical block "smudges" with the charcoal stick instead of drawing an outline, as we have done here. Then, draw the contours with pencil (graphite or charcoal pencil) and erase any exterior charcoal smudges with a rag or kneaded eraser. The remaining charcoal left on the paper naturally suggests volume.

A Draw a solid geometric shape with a charcoal stick to indicate the basic structure. Use the side of a small piece of charcoal in order to cover the most surface area.

B Trace the contours of the shape with a charcoal pencil, which is denser and more permanent than a charcoal stick.

C Partially erase overlapping charcoal areas outside of the outline with a rag or kneaded eraser.

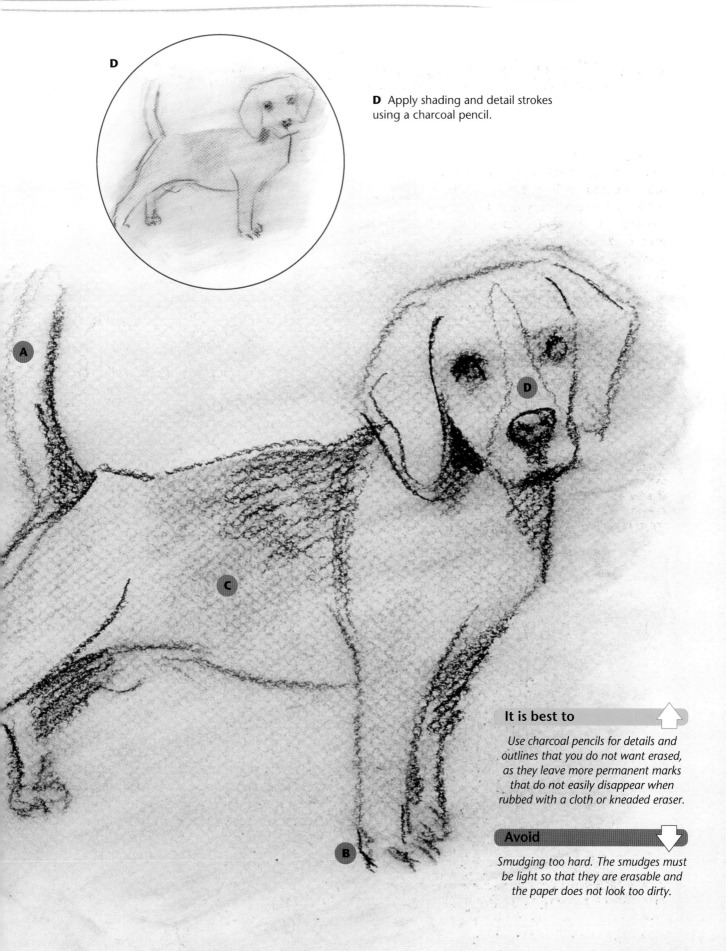

D Apply shading and detail strokes using a charcoal pencil.

It is best to

Use charcoal pencils for details and outlines that you do not want erased, as they leave more permanent marks that do not easily disappear when rubbed with a cloth or kneaded eraser.

Avoid

Smudging too hard. The smudges must be light so that they are erasable and the paper does not look too dirty.

From smudge to line

The way to outline with charcoal sticks that we propose here involves going from the smudgemark to the line, the opposite of what is usually done. But the potential effects of charcoal sticks allow us to do this. These charcoal smudges can contain the lines of a future drawing; the artist just has to discover them. It is easier to find those lines in a smudge than on a sheet of paper that is completely blank.

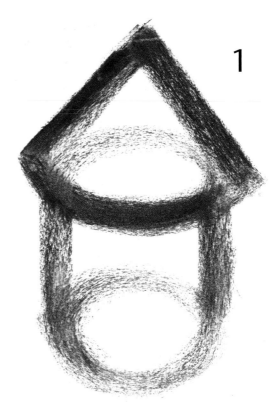

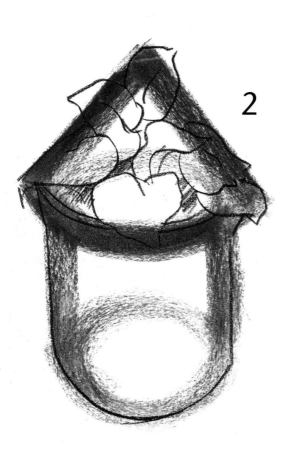

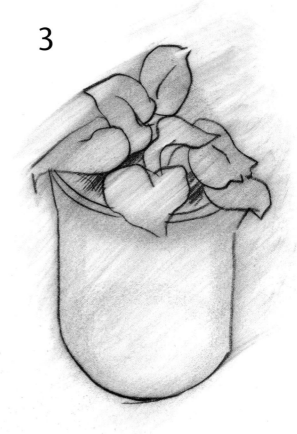

1 We draw the basic outline with a thick stroke of the charcoal stick, applying the flat edge of the stick to the paper. We started this potted plant image with a cone placed on top of a cylinder.

2 On top of the cone we draw the leaves of a plant, using a charcoal pencil or stick. We also trace over the cylinder's shape (the pot), with strokes of charcoal.

3 Finally, we erase everything with a rag, making sure that only the dark lines are visible.

These two drawings were done using the charcoal stick outlining method, which can be especially effective for quick sketches.

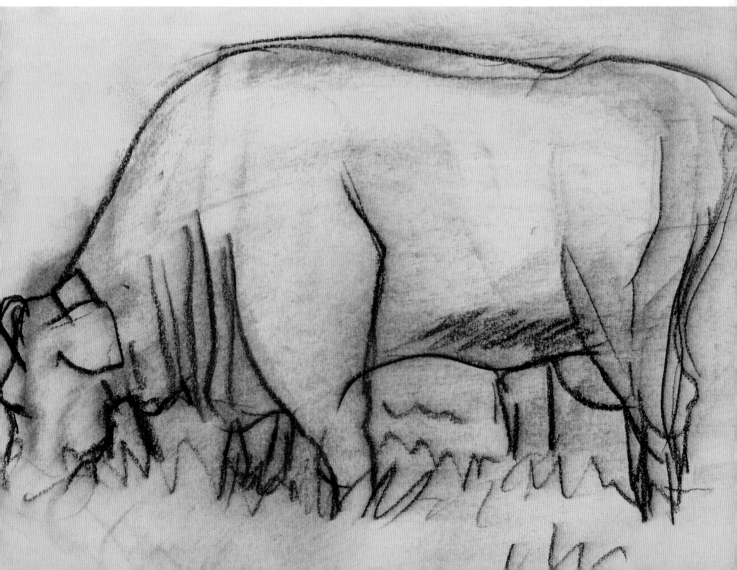

Outlining with color pencils allows us to harmoniously integrate the colors in a drawing, as the outlines and interior strokes form an integral part of the overall color scheme. In this sequence, we use color pencils in the warm range (red, orange, ocher, and brown), plus some touches with a cool tone (blue). When we work with color pencils, the shift from the outline of the figure to the contour lines is a simple matter of adjusting the shape and size of the figure.

Outlining in color

1

2

1 This is an outline made up of basic shapes similar to those already described in the preceding pages. We have drawn it with red and orange colored pencils.

2 After defining the cat's face a little more, we draw zigzag lines to suggest fur and the volume of its body.

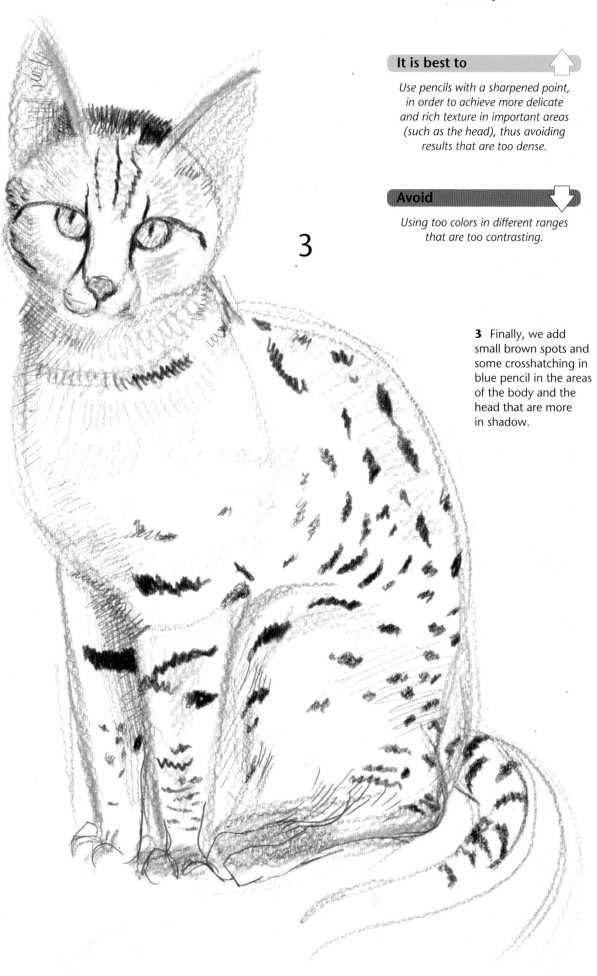

Use pencils with a sharpened point, in order to achieve more delicate and rich texture in important areas (such as the head), thus avoiding results that are too dense.

Avoid

Using too colors in different ranges that are too contrasting.

3

3 Finally, we add small brown spots and some crosshatching in blue pencil in the areas of the body and the head that are more in shadow.

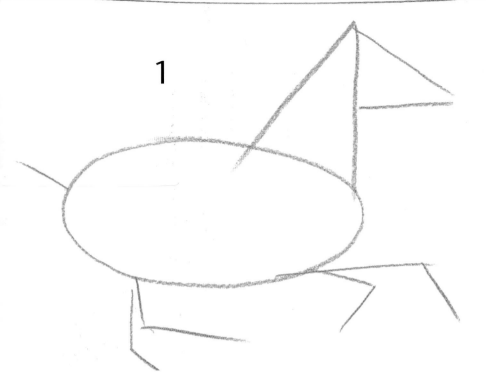

1

To represent a shape in motion, such as this galloping horse, the outline follows a process identical to that in the previous exercises—but we must now make sure that the drawing includes effective indications of movement. One possibility is to leave the contours unfinished in order to suggest rapid movement. Here, we have chosen the simplest way, which consists of emphasizing the flying mane and highlighting the outstretched legs with some shading in blue pencil.

Outlining to show movement

1 An oval, two triangles, and some straight strokes are used to convey movement. The proper placement and adjustment of each part is crucial to achieving the desired effect.

2 We go over the contours with more naturalistic strokes but without losing the pattern suggested by the shapes of the initial outline.

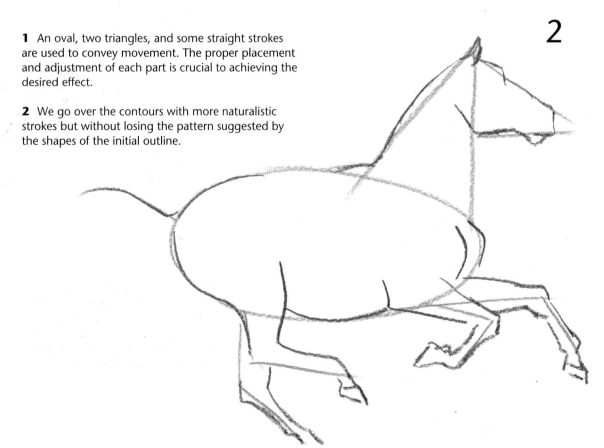

2

It is best to ⬆

Draw lightly, without redoing lines or taking too long drawing them in order to avoid unsteady strokes.

Avoid ⬇

Finishing the contours completely by using a continuous line. Movement is shown much more clearly through lines that suggest some discontinuity.

3

We recommend that you use vibrant colors for emphasis, such as red or blue, if working on white paper; light colors tend to get lost on the page.

3 After the contours are finished, we underline the flying mane using intense strokes, which add intention and dynamic energy to the drawing. We emphasize the pupils in order to show a more natural expression.

Strokes and movement

A drawing that shows movement can contain errors that are not noticeable because of the energy and decisiveness of the strokes; in contrast, excessive concern with the correctness of the strokes can produce a rather static result, which, in turn, can destroy the desired effect. So it is best to draw with resolve and not be afraid of making mistakes. The energetic movements of the hand are suggestive of movement in itself. Using a nib pen encourages a sense of determination, since it is impossible to erase the strokes.

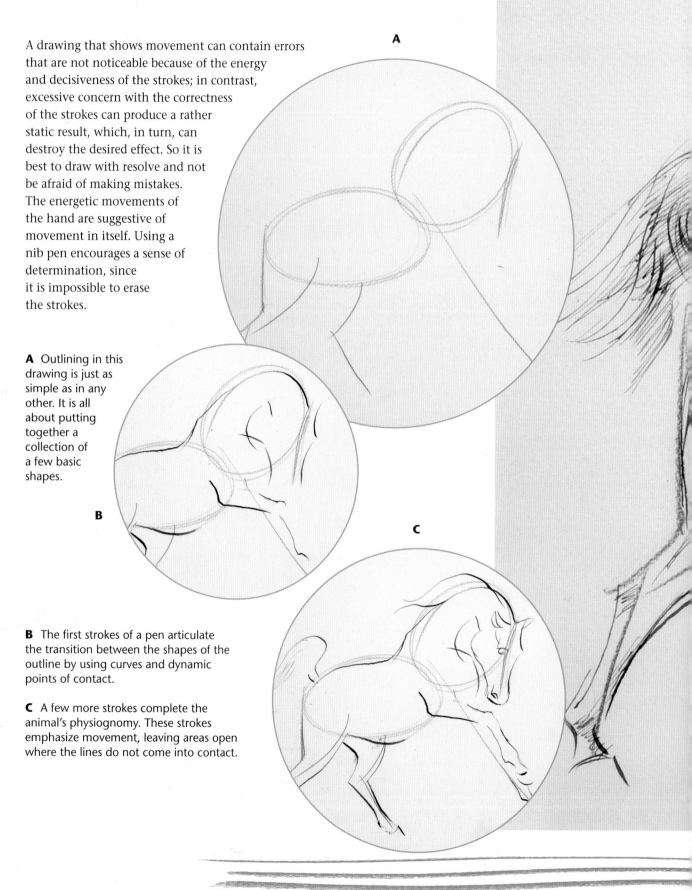

A

B

C

A Outlining in this drawing is just as simple as in any other. It is all about putting together a collection of a few basic shapes.

B The first strokes of a pen articulate the transition between the shapes of the outline by using curves and dynamic points of contact.

C A few more strokes complete the animal's physiognomy. These strokes emphasize movement, leaving areas open where the lines do not come into contact.

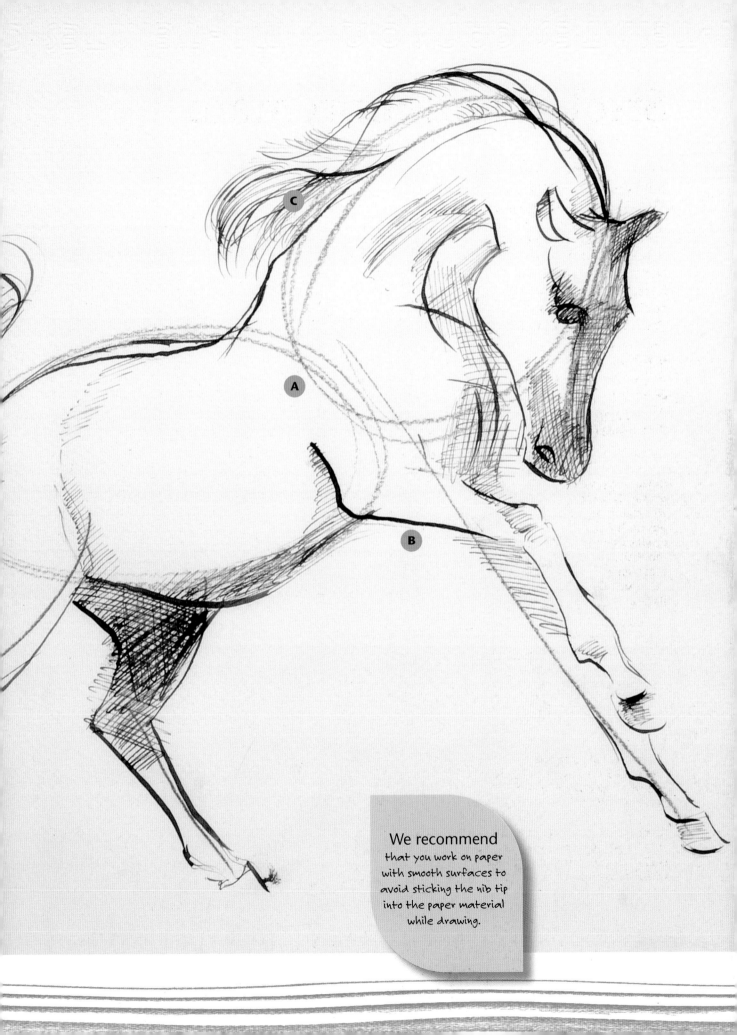

We recommend that you work on paper with smooth surfaces to avoid sticking the nib tip into the paper material while drawing.

Proportions of the head

The human head requires special study as it forms the basis for a genre in itself: the portrait. The outline of the head and the face requires special attention to proportion. The shape of the outline is an exact oval, which, when divided into consecutive halves, allows us to find the harmonious position of the eyes, eyebrows, nose, mouth, and ears, both in full frontal and profile positions.

1 The head can be sketched using an oval (an inverted egg), which is about two-thirds as wide as its height.

2 Facial features are located on the lower half of the oval: we first trace the mid-line and then we draw a line dividing the bottom section in half. Next, we divide this lower half into two additional halves.

3 We then divide each of the two side halves of the width in half.

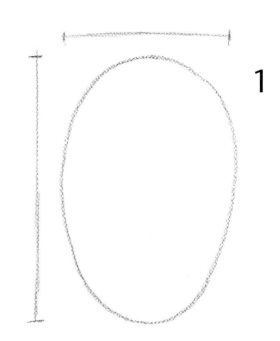

1

2

3

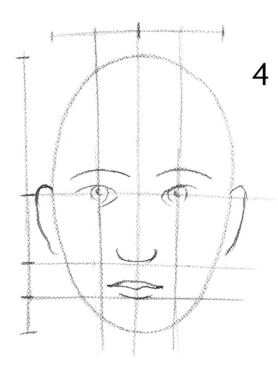
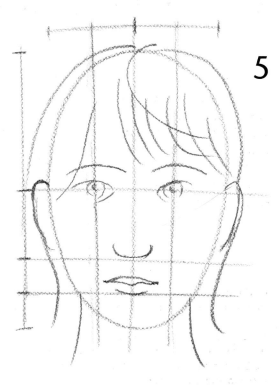

4 We place the eyes (two small ovals) on the intersection of the side vertical lines and the horizontal line, which divides the oval. Ears are drawn at this same height, and the nose and mouth on the lower half.

5 We cover the upper half with strokes suggesting the style and direction of the hair, depending on the gender and age of the figure.

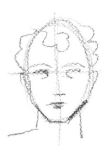
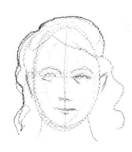

Gender and age are typically indicated by the softness or angularity of the chin; women and children have rounder contours.

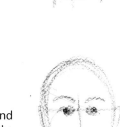
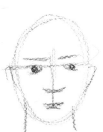
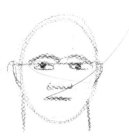

By varying the space and dividing lines of the face slightly, we can depict different facial features and expressions.

Once you have practiced the exercise on the previous page, you will have a sense of the basic proportion of the face and head; here we will simplify the procedure using horizontal lines only. Carefully consider the particular facial features of your subject:
Are the eyes close together or father apart?
How long is the nose and is it wide or narrow? Are the lips thin or full? Are the eyebrows straight or arched?

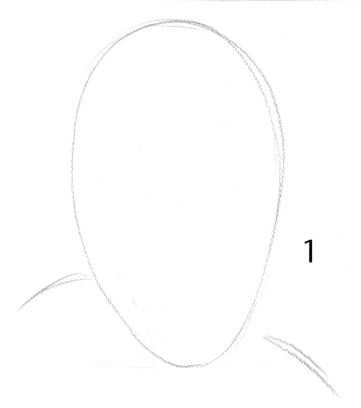

1

Portrait outlining

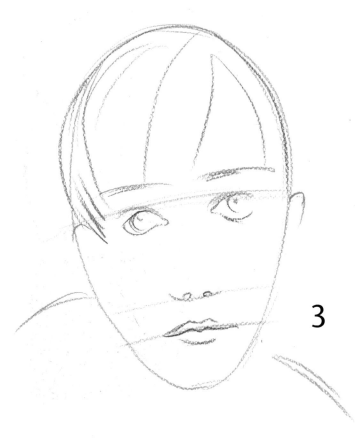

3

2

1 We draw the oval with some simple lines to define the height of the shoulder: in this case, the figure looks at us from a position below us.

2 We mark the horizontal divisions of the oval to place the features on these lines. We have increased the distance between the height of the eyes and the mouth.

3 After we have decided on the distance between the features, we depict them using very simple shapes: elongated lines and ovals.

4 We draw the hair and details of the jacket with intense strokes. We emphasize the pupils in order to animate the expression.

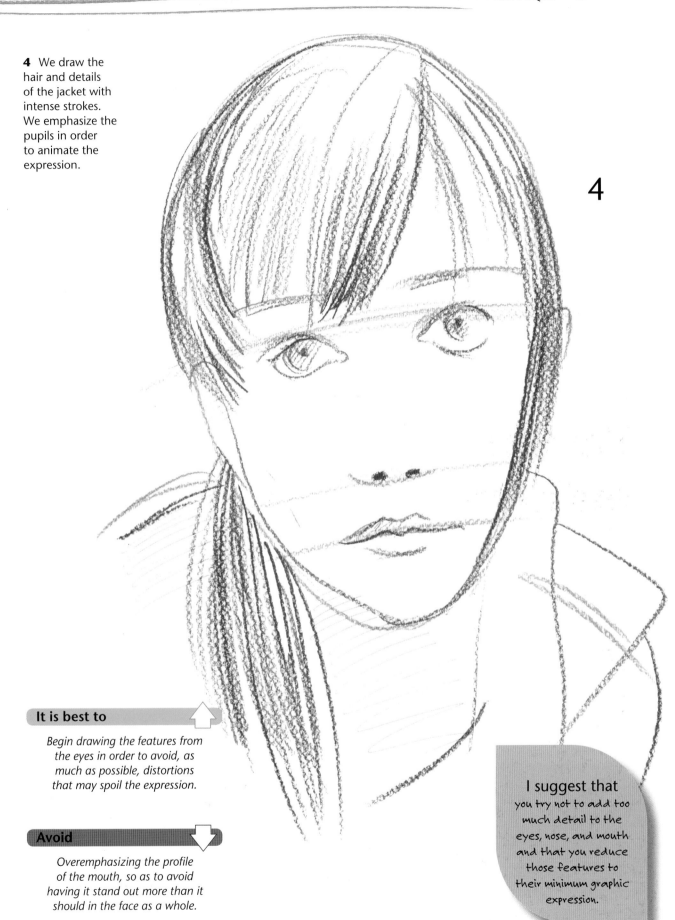

4

It is best to

Begin drawing the features from the eyes in order to avoid, as much as possible, distortions that may spoil the expression.

Avoid

Overemphasizing the profile of the mouth, so as to avoid having it stand out more than it should in the face as a whole.

I suggest that you try not to add too much detail to the eyes, nose, and mouth and that you reduce those features to their minimum graphic expression.

Head in profile

The drawing of a head in profile is simpler than that of a full frontal view of the head. It is not necessary to worry about the symmetry and relative position of the features on each side of the face: it is enough to keep in mind the dividing lines of the subject's height and draw contours that are characteristic of the facial features in their proper proportion.

But we always keep in mind that the oval of the head remains tilted, with respect to the vertical line of the neck.

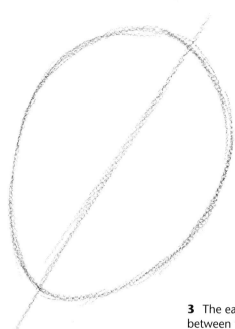

1

1 We draw an oval (an inverted egg shape) whose axis follows a diagonal line.

2 We mark the vertical dividing lines using horizontal lines: three successive halves where we will insert the facial features on the point of intersection between the horizontal lines and the outside of the oval.

3 The ear is inserted in the distance between the height of the eyes and that of the lower part of the nose. Finally, we draw the contours of hair by covering the curve of head.

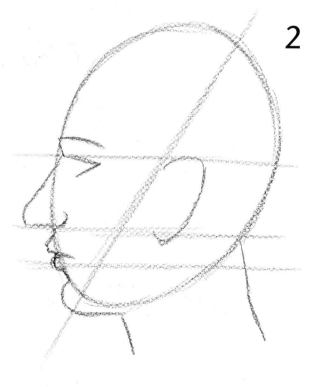

2

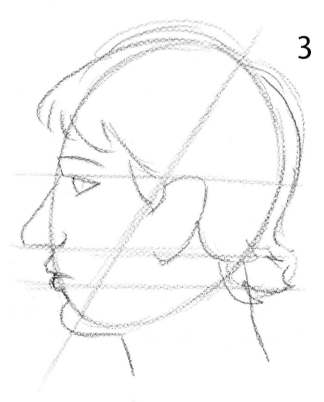

3

1 The shape of the nose may slightly stand out from the oval curve, depending on the individual physiognomy.

2 In a well-outlined head, we can highlight those features we think appropriate, taking the basic proportions in account.

3 Here, the highlighted curls on the head give the facial expression its own unique character.

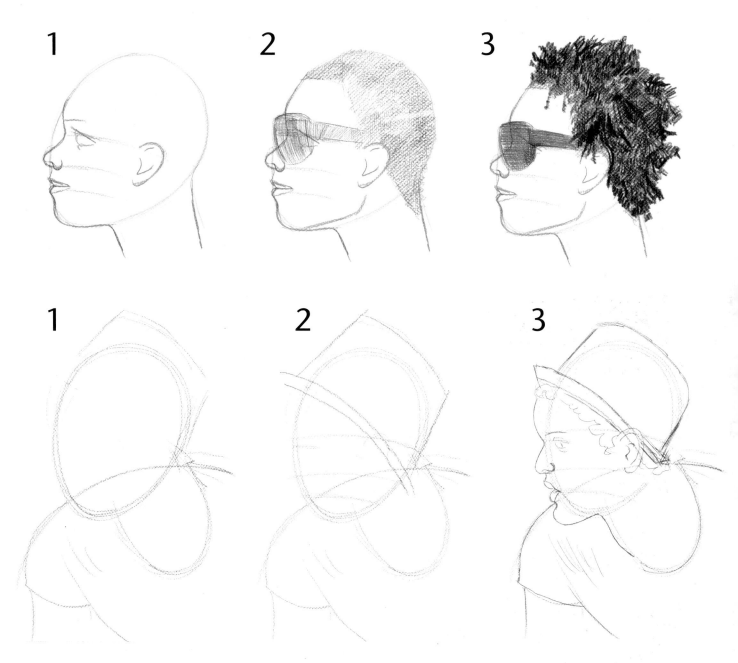

1 Gesture and movement are achieved by articulating the head over the neck and shoulders, consistent with the features of the figure.

2 The outline of the hat covers the upper half of head almost completely.

3 The features in profile always occupy the lower area of the oval of the head.

When drawing a portrait of a child, take into account the fact that the proportions of a child's head are not the same as the proportions of an adult's head. A child's features occupy a proportionately smaller place in the volume of the head than the features of an adult, which is why a child's head looks slightly larger. To accomodate this change in proportion, the divisions in the oval outline have been slightly modified.

Profile of a child

1 When we draw the initial oval, we should keep in mind that a child's head is proportionately larger than the head of an adult, in regard to its body.

2 We draw lines to allow us to place the features: half the height of the oval into two successive halves.

3 We place eyebrows and eyes under the mid-line. We place the rest of the features on the dividing lines.

1

2

3

We recommend
that you practice these exercises using photos of heads in different positions, both profile, frontal, and for a challenge, three-quarter profile.

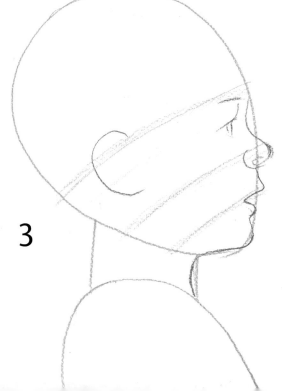

4 Finally, we cover the head by drawing the hair. The face looks smaller with respect to the head as a whole, which is normal for children.

4

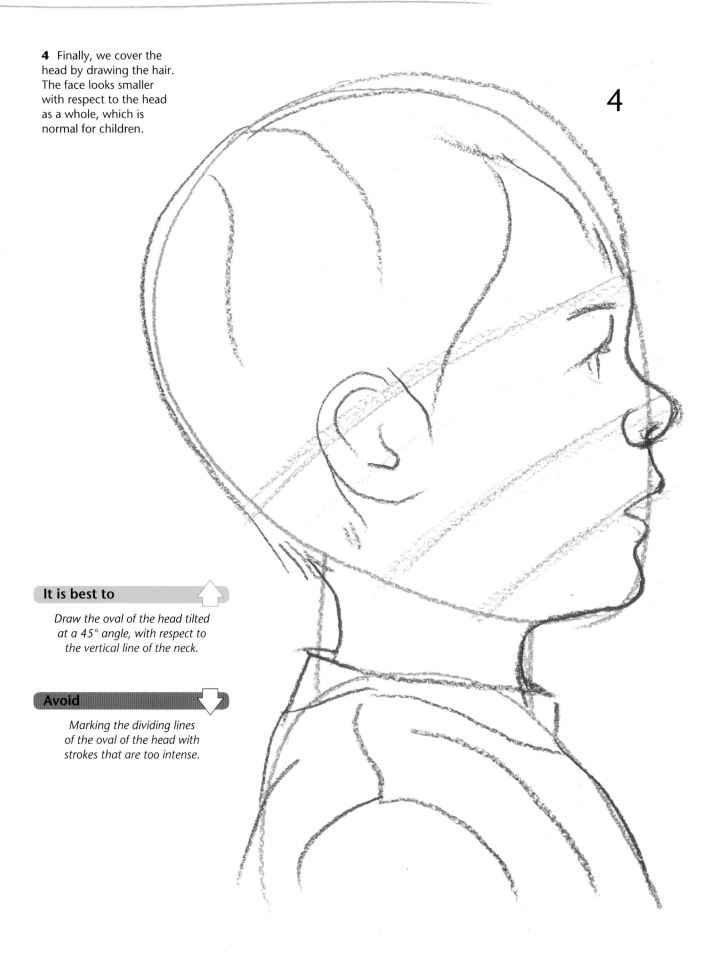

It is best to

Draw the oval of the head tilted at a 45° angle, with respect to the vertical line of the neck.

Avoid

Marking the dividing lines of the oval of the head with strokes that are too intense.

Head and expression

Expression is an inseparable aspect of the human body and, especially, in particular, of the face. A person's facial expression influences the placement and movement of his or her features: the slope of the mouth, the direction of the gaze, the arching of the eyebrows, the wrinkling of the brow, and so on.

The slightest indication of these elements can be enough to achieve a maximum of expression.

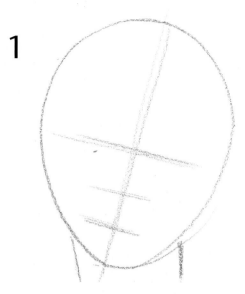

1 We draw the oval of the face tilted to one side, indicating the neck with vertical lines marked underneath. We divide the face in half with a line echoing the tilt of the head, and add parallel marks to this line to position the eyes, nose, and mouth.

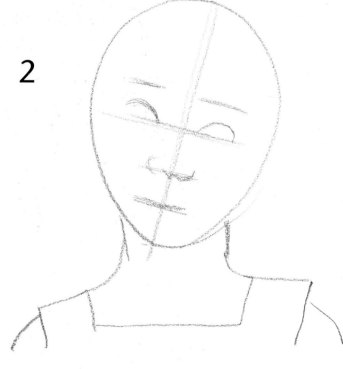

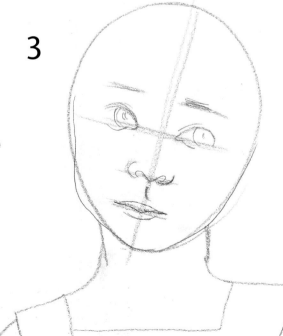

2 We draw the features over the divisions of the face. We exaggerate their size, enlarging the proportion of the eyes. For a wide-eyed expression, we place the eyes slightly higher, above the mid-line.

3 We shift the placement of the eyeballs to the right, so she appears to be looking at something or someone to her left.

4 The hair on the head is drawn very simply with long wavy lines, which is key to creating the final expression.

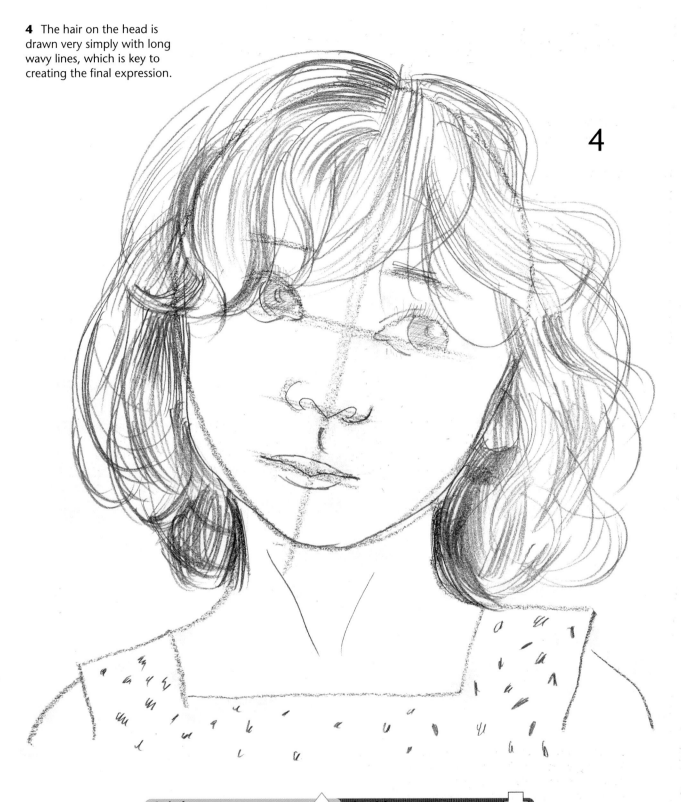

4

It is best to	Avoid
Exaggerate the layout of proportions, suggestive of a "caricature" of the child's face, in order to ensure that the expression comes through.	*Exaggerating the openness of the eyes in order to avoid an overly sentimental expression.*

The purpose of shading is to give volume and dimensionality to a subject, but shading can also help to illustrate the space itself around a subject. Shading basically consists of creating areas varying in intensity of lightness and darkness, depending on the drawing tool used. In this example, we have used a soft graphite pencil and the shaded areas are crosshatched: the building up of straight, parallel strokes, superimposed in different directions.

Shading with pencil

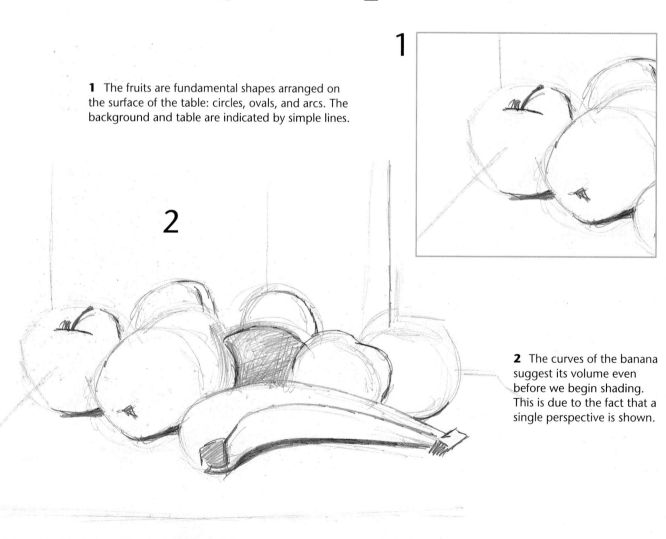

1 The fruits are fundamental shapes arranged on the surface of the table: circles, ovals, and arcs. The background and table are indicated by simple lines.

2 The curves of the banana suggest its volume even before we begin shading. This is due to the fact that a single perspective is shown.

3

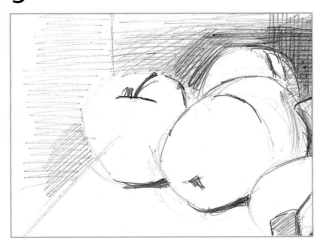

3 Aside from the small stem that defines the nature of the fruit, crosshatching in pencil strokes rounds out its volume from the outside.

4 For this apple, we build up pencil strokes to create very dark shading that acts to highlight the sharp outline of the fruit and give dimension to its volume.

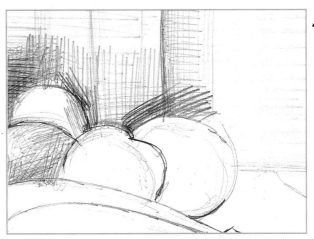

4

It is best to ⬆

Begin shading with light crosshatching that consists of separated lines, and then to continue with more intense crosshatches placed closer together.

Avoid ⬇

Finding many different shades of gray: it is preferable to have a few tones that contrast sharply with each other.

5 Shading in pencil with hatchmarks is easy. It consists of covering the paper with a series of parallel strokes in the form of a mesh or net, whether crossed or not, until a good arrangement of lighting and shading is achieved. The original drawing can be as much of a sketch as we wish.

5

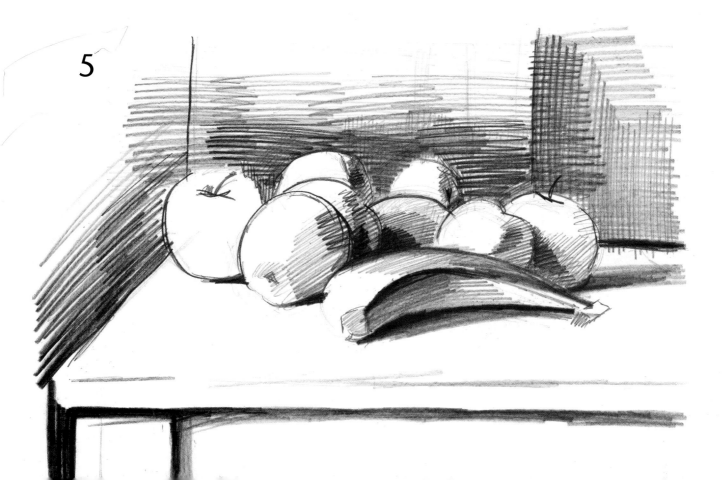

Shadows and crosshatching

This exercise allows us to appreciate the process of crosshatching using a graphite pencil. We begin with a basic sketch that we will continue to enhance as we add additional characteristic details. When we feel that we have added enough details, we begin to shade with crosshatching. All crosshatching here involves straight lines, except for the strokes in the center of the flower, which follow a slight curve in order to represent the shape and texture of the sunflower.

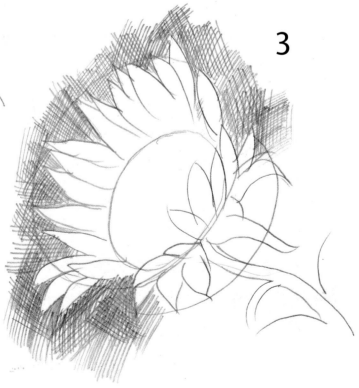

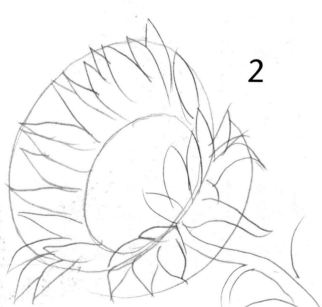

1 The drawing's initial outline is as simple as these ovals placed on different planes: one belongs to the corolla and the other to the center of the flower.

2 Using the lines in the basic pattern, we arrange the petals and leaves of the flower by just drawing lines.

3 Crosshatching is done by using crossed lines, which highlight the flower's shape and relief. For the sunflower's corolla, we use cross-hatching with curved lines in order to give the flower its special shape.

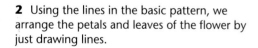

4 Finally, we darken the leaves and the stem with thick strokes so that they contrast with the distinctive shape of the flower. Likewise, we include some free strokes in the petals to make them stand out.

4

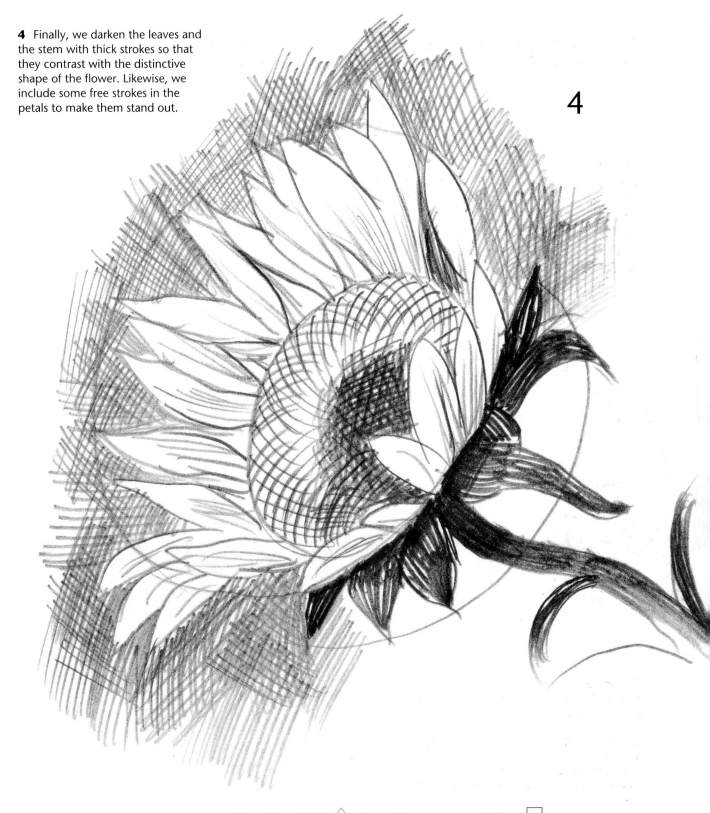

It is best to	Avoid
Draw all the contours before starting to crosshatch. Only this way will you know which areas you are shading.	*Begin the crosshatching with very energetic strokes: you have to work from less to more, first the soft strokes and then the dark ones.*

Now let's study this drawing. You will see that it is not completely uniform: some areas are completely shaded, while others only show the contours that have been drawn. This variation provides visual interest to the piece. As with most pencil drawings, the shading is done using crosshatched strokes. Some crosshatching is more dense than others, which enhances the relief of the object and the effects of volume and spacial depth.

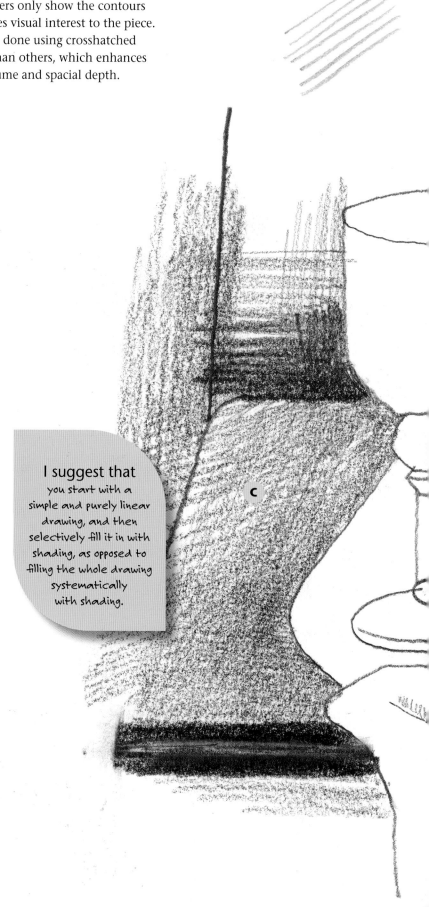

Shading variation

One of the elements that makes this drawing interesting is that there are "unfinished" areas without shading. This also makes it easier to follow the process we undertook from the initial sketch to the final shading.

A In this area, the shadows are simple diagonal strokes done by barely pressing the tip of the pencil on the paper.

B In the background, the shadows are graduated in intensity, that is, there are very soft strokes at the top that progressively intensify as they move towards the bottom.

C Here we cross two groups of soft diagonal strokes in order to create the texture of the table.

D We draw the darkest shadows using very intense strokes, pressing the tip of the pencil very hard on the paper.

E This is the only shading that is included in the central foreground area: it consists of tiny vertical strokes.

I suggest that you start with a simple and purely linear drawing, and then selectively fill it in with shading, as opposed to filling the whole drawing systematically with shading.

B C D E

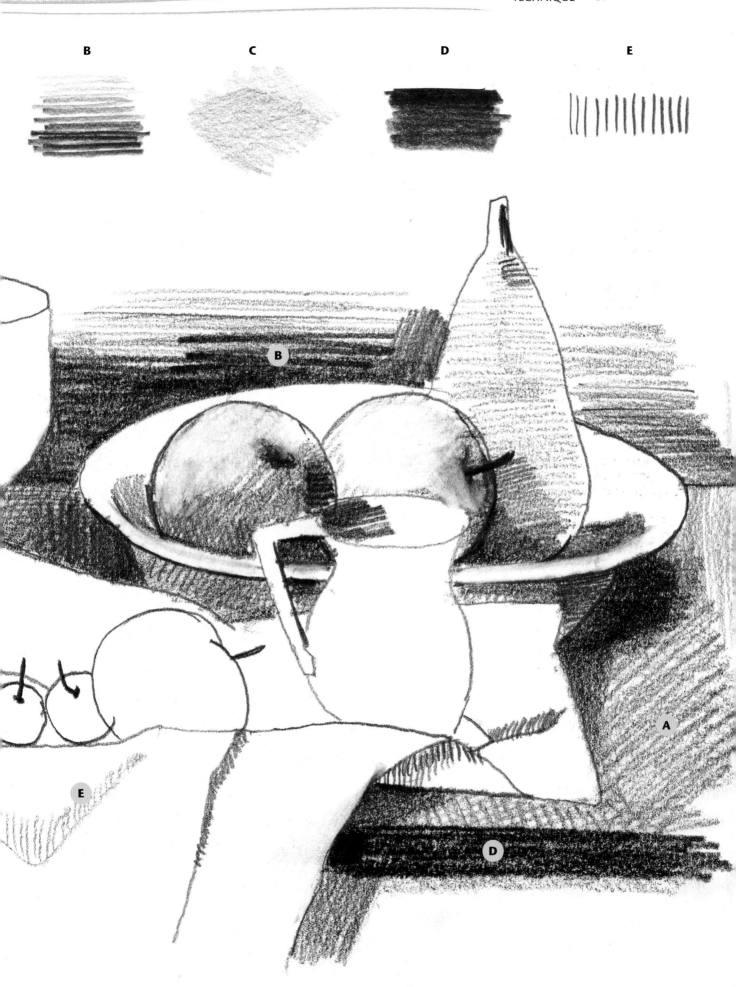

From a linear sketch to a drawing in relief

In order to achieve a three-dimensional effect, it is best to contrast crosshatched areas with blank areas, as shown in the drawing on pages 56–57. The lines in the initial sketch should be enough to define the brightest areas, in which only the stark contours of the subject can be discerned. The crosshatching should be done in the areas opposite the light; the less exposed they are to light, the darker they should be. For round objects, the maximum darkness appears in the lower part of their "belly."

1

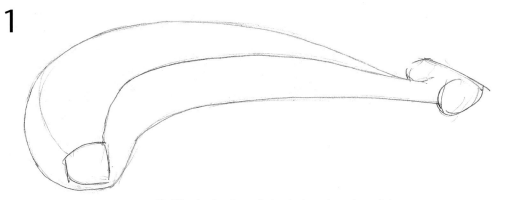

1 We drew a banana with a few curved lines. We do not need to draw a geometric sketch beforehand, since it is already such a basic shape.

2 We shade strongly to darken the edge of the fruit above the side that has more shading and crosshatching. We also crosshatch the bottom energetically, especially underneath the banana.

2

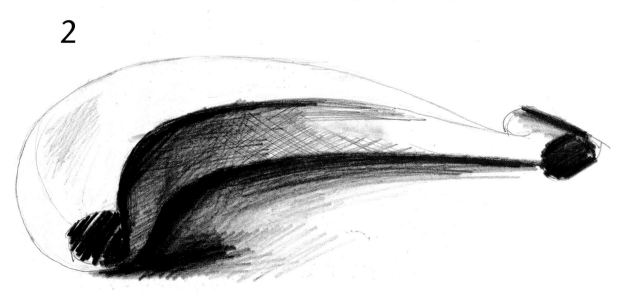

1 A simple drawing of a pitcher with flowers created solely with lines. The lines used for the flowers are free-form undulating curves.

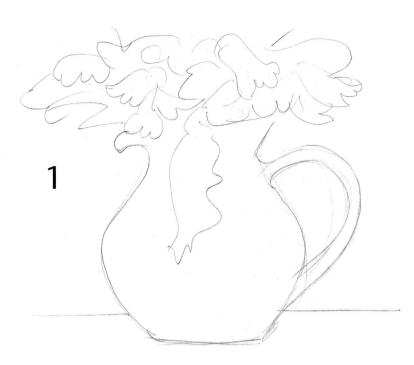

It is best to ⬆

Begin with very soft feathering, spreading the media with your fingertips or a cotton rag, or a special tool called a smudge stick.

Avoid ⬇

Retracing the contours with thick strokes. This isolates the shapes, causing the drawing to lose its light touch.

2 The crosshatching is densest in the lower part of the pitcher; the crosshatches that are especially dark, just above the bottom, emphasize the area that is least exposed to light.

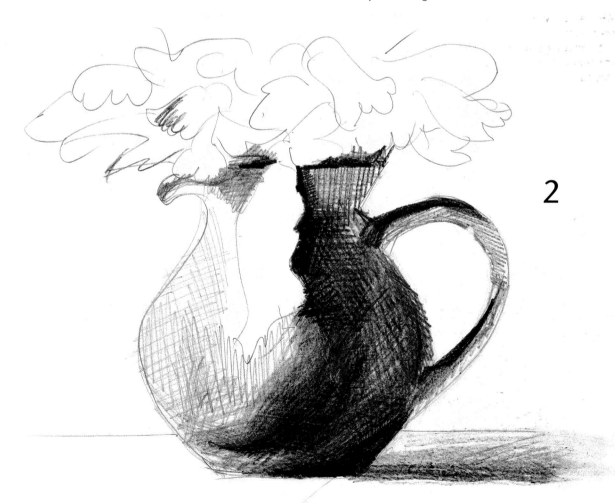

Shading with charcoal pencil

Charcoal pencil is a darker medium, more dense and less soft than charcoal sticks. It allows you to finish contours more quickly and achieve very defined contrasts between light and dark. The black tone of the charcoal pencil is really black, not a dark gray like that of a charcoal stick. This exercise and the ones on the following pages demonstrate a very easy way to handle shaded objects using charcoal pencils.

1 Let's draw a pitcher. We just need to create a sketch first, since its shape is simple and allows for small flaws that will not ruin the final result.

2 We trace an imaginary line that divides the object in two: the part that is well lit and the part that lies in the shadows. Let us also draw the contours of the shadow that the object projects on a hypothetical wall.

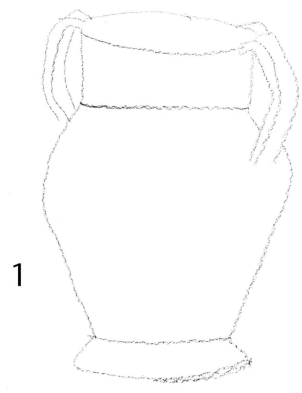

1

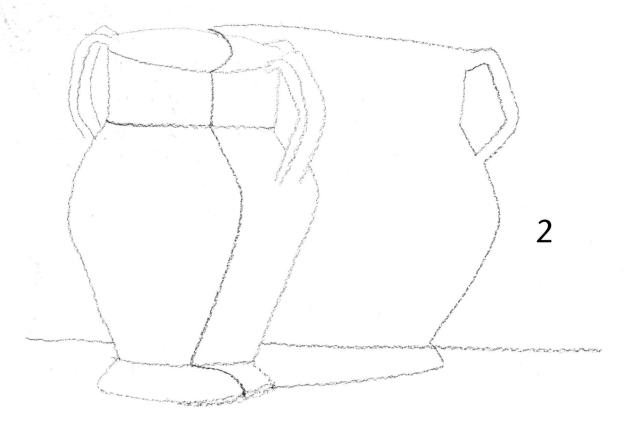

2

It is best to 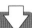	Avoid
Clearly define the limits of the drawing and those of the contours of the shadow projected by the object.	*Smudging or feathering the drawing. This exercise, and the next one, are based on shading that involves black-and-white areas in sharp contrast.*

3

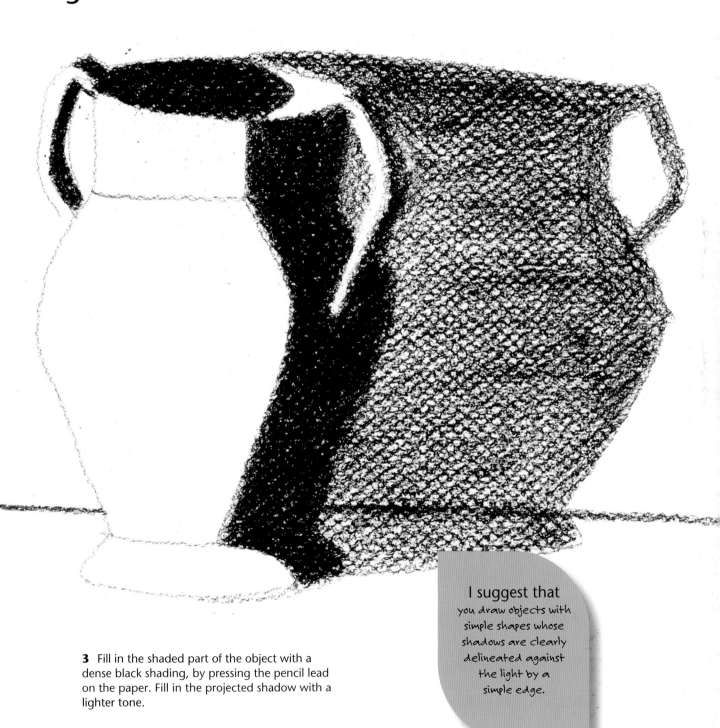

3 Fill in the shaded part of the object with a dense black shading, by pressing the pencil lead on the paper. Fill in the projected shadow with a lighter tone.

I suggest that you draw objects with simple shapes whose shadows are clearly delineated against the light by a simple edge.

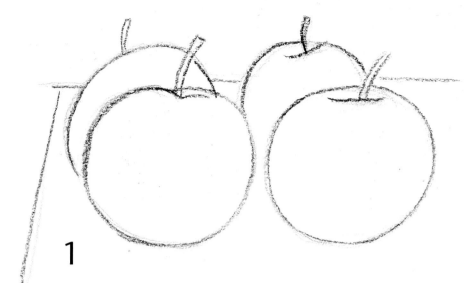

1

Chiaroscuro is a form of shading that creates maximum contrast between light and shadow. A charcoal pencil allows us to achieve a chiaroscuro effect easily. This process is very similar to the previous exercise. In this case, the position of some objects, placed in front of others, makes it possible to accentuate relief and depth.

Chiaroscuro effects

1 Let's draw four apples on a table. This is a basic drawing that can be done with a graphite or charcoal pencil.

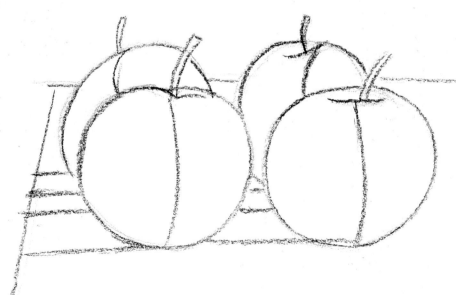

2

2 Draw imaginary lines that divide the lighted areas from the shaded ones, for the area in between the apples as well as on the table.

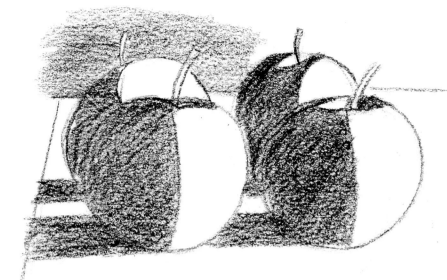

3 We shade the part that is in shadow with soft strokes of charcoal pencil; we also darken the top of the drawing to highlight the parts of the fruit that are exposed to light.

4 We press hard with the pencil in the darker areas of each apple and the shadows that they project until we achieve a black opaque color. In the background, we emphasize the shadow of the table, which makes the back edge stand out.

3

4

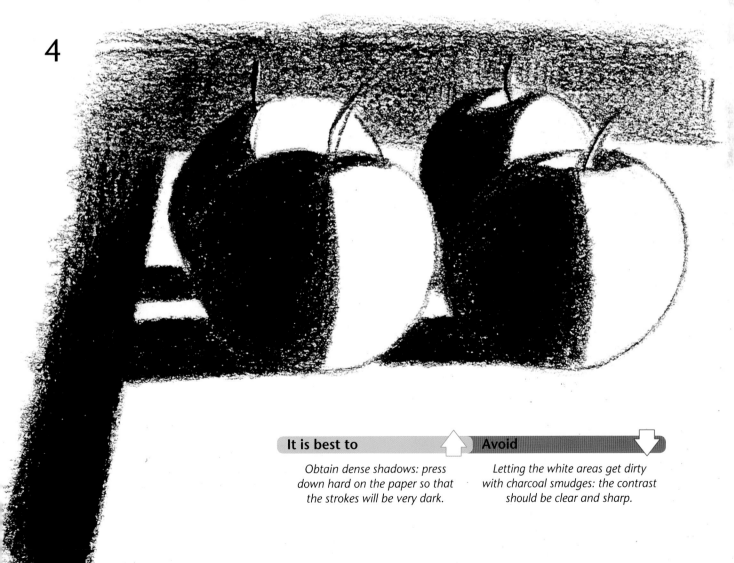

It is best to ⬆	Avoid ⬇
Obtain dense shadows: press down hard on the paper so that the strokes will be very dark.	*Letting the white areas get dirty with charcoal smudges: the contrast should be clear and sharp.*

Transition from light to shadow

One of the most important keys to shading is the transition from light to shadow, which allows you to see the shape of the object represented as well as its dimension. In this exercise, which is done with a charcoal pencil, we draw a leaf shoot so that so that its curlicues are clearly shown in relief.

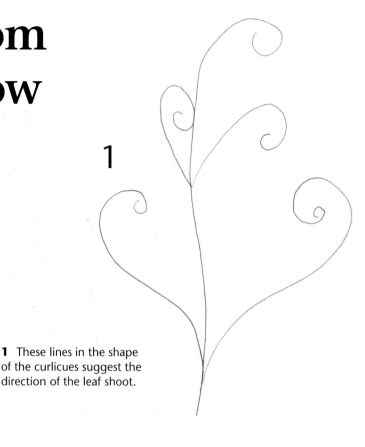

1 These lines in the shape of the curlicues suggest the direction of the leaf shoot.

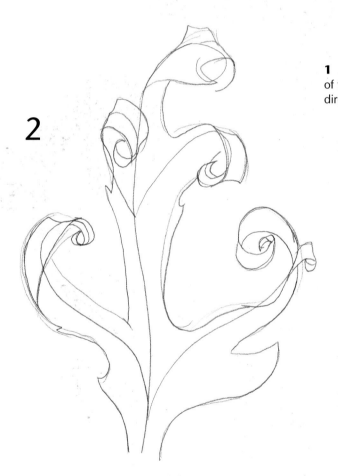

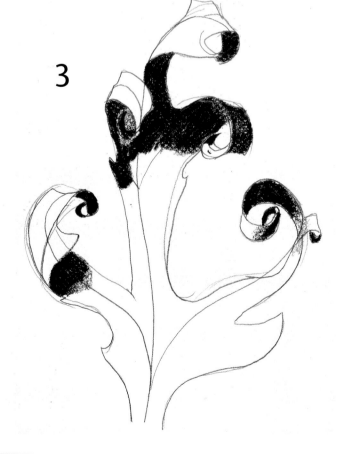

2 Now we try to give three-dimensionality to the curlicues by drawing parallel lines that curl up in a similar manner.

3 We then shade the highest points with more intensity, especially those that are curled up.

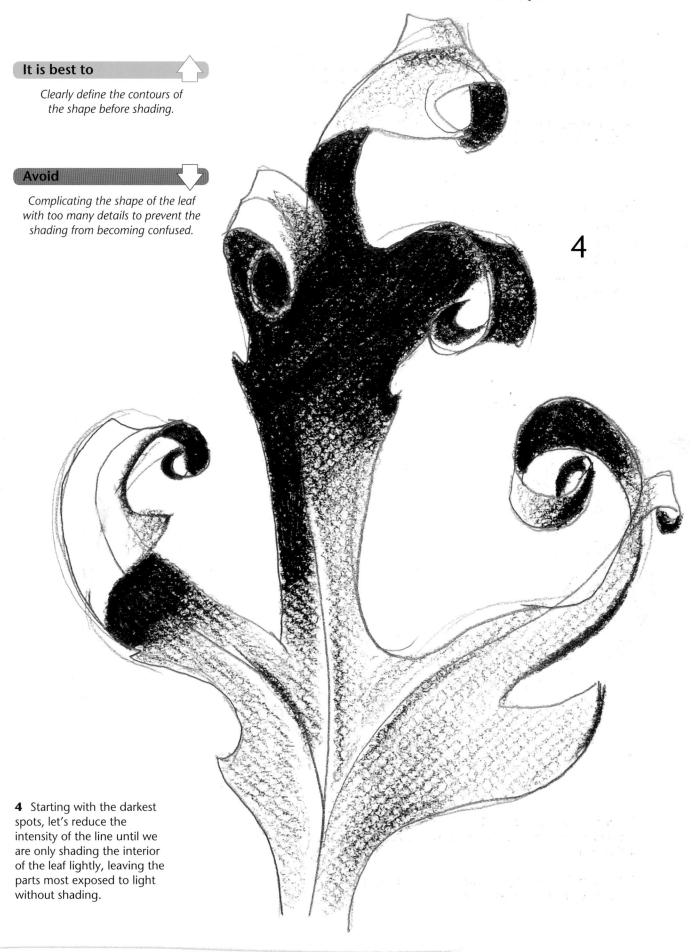

It is best to ▲

Clearly define the contours of the shape before shading.

Avoid ▼

Complicating the shape of the leaf with too many details to prevent the shading from becoming confused.

4

4 Starting with the darkest spots, let's reduce the intensity of the line until we are only shading the interior of the leaf lightly, leaving the parts most exposed to light without shading.

Shading with sanguine

Sanguine is usually combined with charcoal to create studies and drawings of the human form, especially nudes.

This process is identical to the one described for charcoal pencil. These two pages show a brief sequence in the process with some examples using sanguine, which, with its warm tones, is particularly suitable for drawing living beings, and specifically the human body.

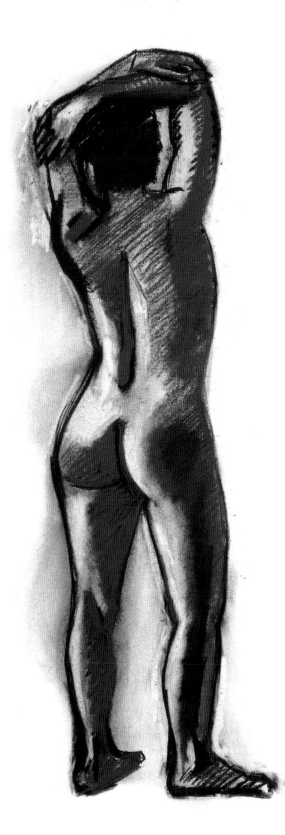

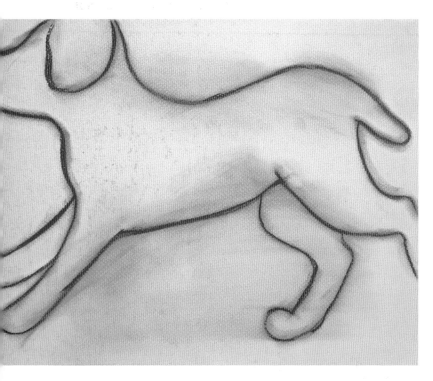

The dense, warm stroke of the sanguine pencil gives personality to very simple drawings because of the graceful nature of lines made with sanguine.

1 Start with the basic outline of a group of objects drawn directly with a sanguine pencil.

2 Starting with the objects in front, let's define the objects by emphasizing the characteristic profile of each one.

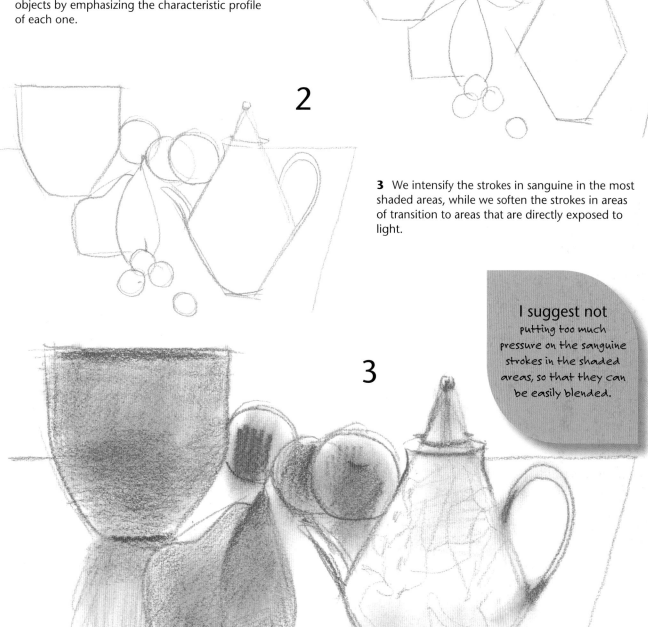

1

2

3 We intensify the strokes in sanguine in the most shaded areas, while we soften the strokes in areas of transition to areas that are directly exposed to light.

3

I suggest not putting too much pressure on the sanguine strokes in the shaded areas, so that they can be easily blended.

Subjects

In the first section of the book, we studied the basic methods to help us create effective drawings. In this second part, we continue studying techniques, but now let's apply them to the most common subjects in artistic drawing: landscapes, still-lifes, and figure drawing.

In reality, any subject can be analyzed into its component parts and divided into small, basic patterns that are easy to draw. The motifs that we propose here can be drawn beginning with those patterns, using various drawing media especially chosen for their particular appropriateness for the subjects selected.

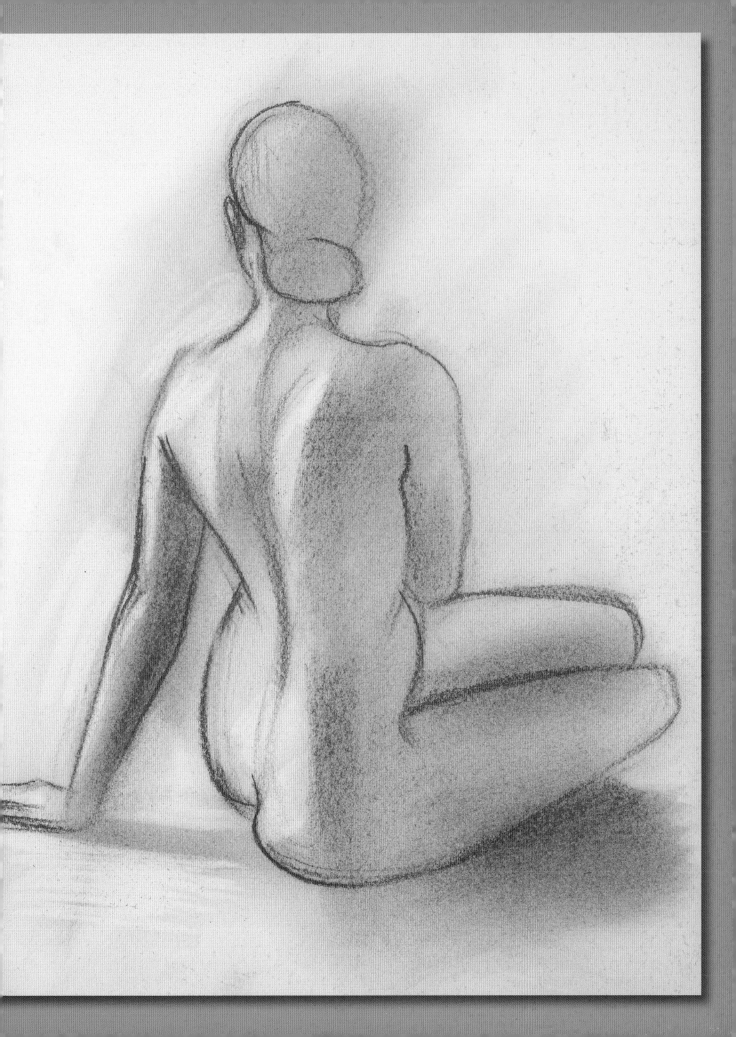

Landscape with pen

When attempting to draw a landscape, it is important to suggest what cannot be literally represented. You do not need to draw each and every leaf or blade of grass. Pen drawings allow us to put this concept into practice, by using crosshatching or systematic shapes repeated in different sizes and positions over the entire surface of the drawing. In this example, let us analyze, one by one, the shapes and crosshatching used in a simple depiction of a landscape.

A

B

C

D

E

A Plants that are the farthest away are evoked with short, curved strokes, like a comma, and are piled up until they suggest a thick appearance.

B The closest plants are drawn using similar strokes, but they are longer and more curved in different directions.

C The bark of a tree trunk can be drawn using straight, choppy segments that are denser where the thickness of the tree requires an indication of shade.

D The smallest leaves in the foliage are patterns in the form of starlike shapes that accumulate in the densest part of the crown of the tree.

E Some areas in the foliage should be represented by starlike forms that are larger in size, so that part of the mass of leaves appears closer.

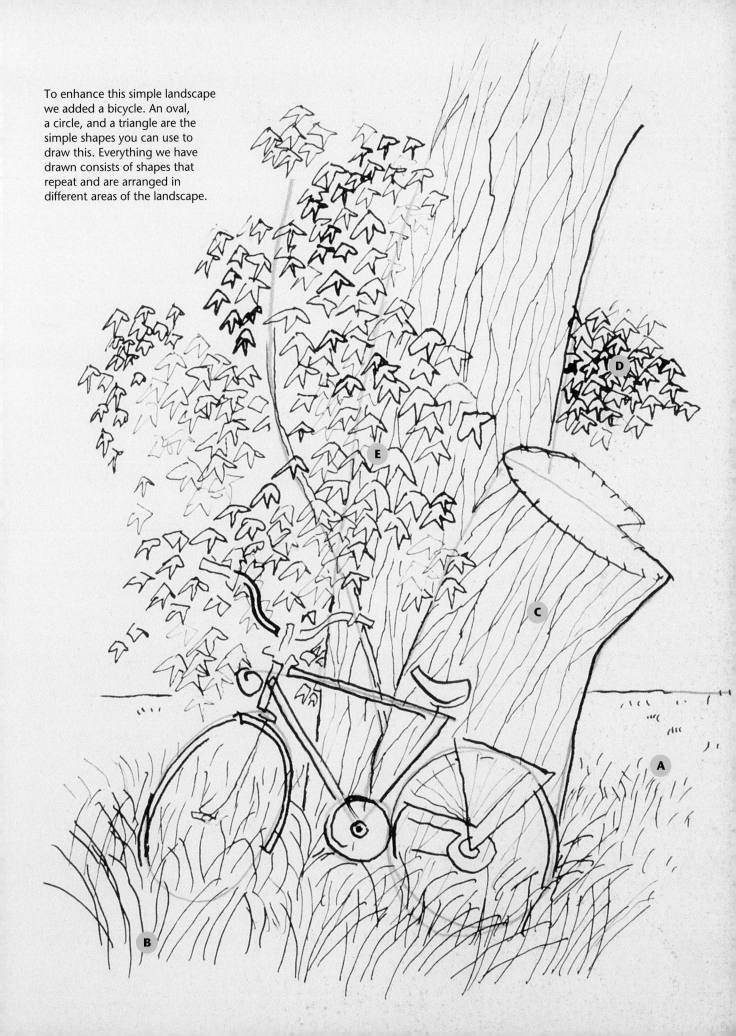

To enhance this simple landscape
we added a bicycle. An oval,
a circle, and a triangle are the
simple shapes you can use to
draw this. Everything we have
drawn consists of shapes that
repeat and are arranged in
different areas of the landscape.

The technique of crosshatching and hatching is not exclusive to drawing with nib pens—it can also be used with pencil drawings. In this sequence, we do not use hatchmarks to create shading, but rather to differentiate different areas of the panorama, to contrast them, and to show their placement within the whole. The degree of darkness of these strokes helps illustrate the distance between the planes of the drawing.

Landscape hatched with pencil

1 We draw the lake with sailboats using wavy lines for the clouds, the boats, and their reflections in the water.

2 We can define the plane of the sky using parallel, horizontal strokes that highlight and show the silhouette of the irregular shape of the clouds.

2

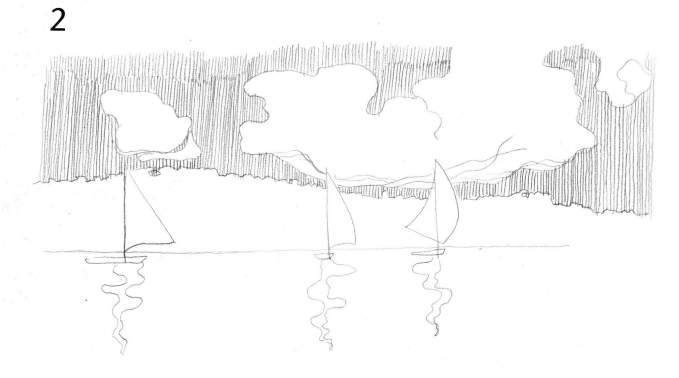

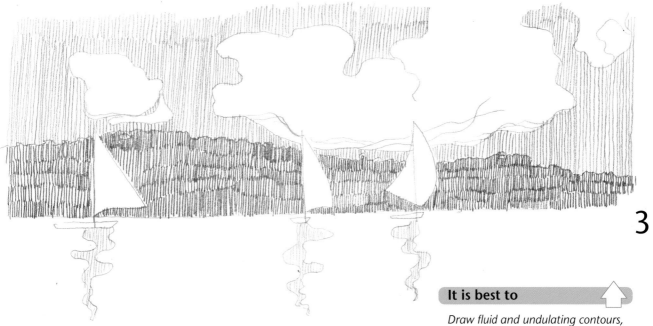

3

3 There are also horizontal lines that fill in the contours of the mountains on the horizon. Here, we use much shorter and tighter lines to suggest a more intense tonality.

4 We conclude this process with horizontal hatching in a darker band on the water (suggestive of a brilliant and smooth surface) and some hatching on the shore.

It is best to

Draw fluid and undulating contours, in order to avoid a drawing that is excessively schematic.

Avoid

Adding other elements that are not made of vertical and horizontal strokes.

4

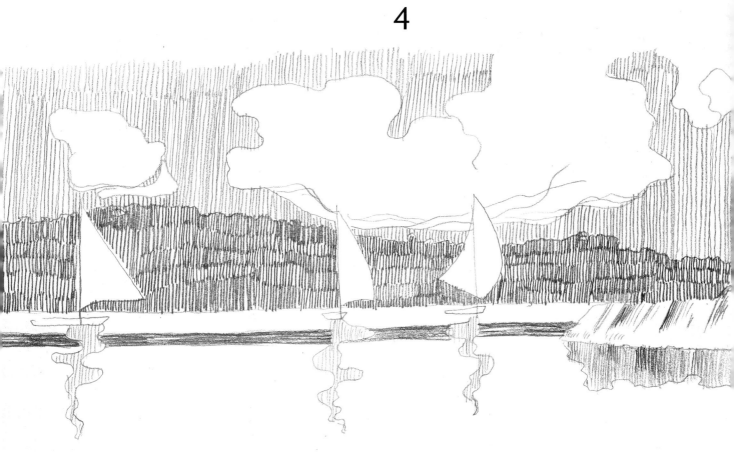

Landscape hatched with charcoal pencil

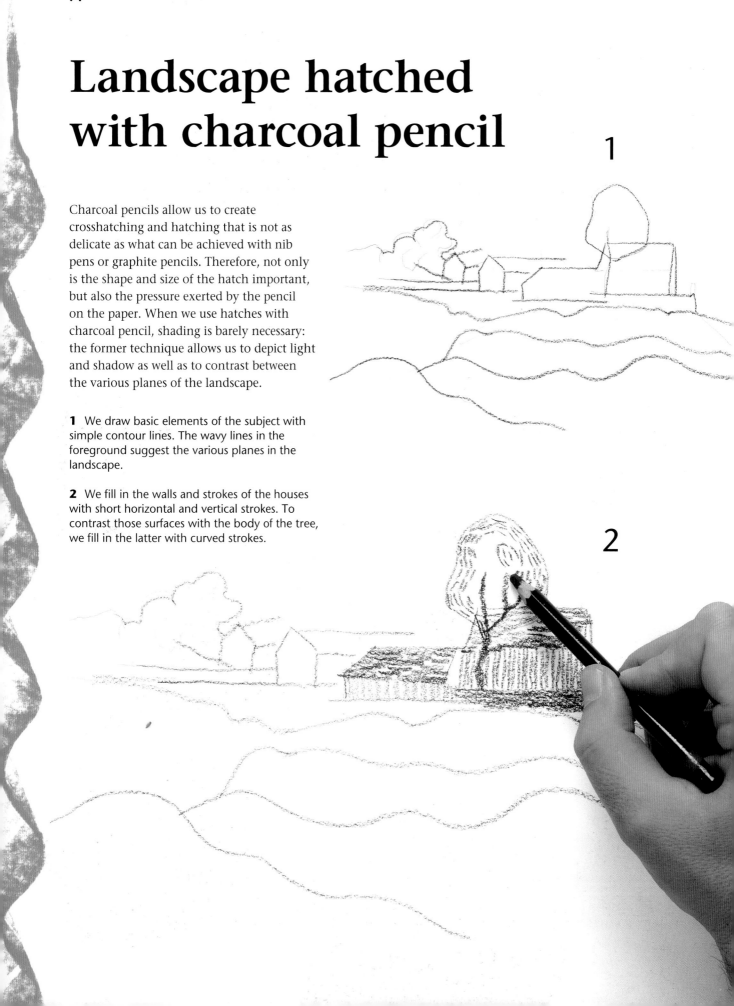

Charcoal pencils allow us to create crosshatching and hatching that is not as delicate as what can be achieved with nib pens or graphite pencils. Therefore, not only is the shape and size of the hatch important, but also the pressure exerted by the pencil on the paper. When we use hatches with charcoal pencil, shading is barely necessary: the former technique allows us to depict light and shadow as well as to contrast between the various planes of the landscape.

1 We draw basic elements of the subject with simple contour lines. The wavy lines in the foreground suggest the various planes in the landscape.

2 We fill in the walls and strokes of the houses with short horizontal and vertical strokes. To contrast those surfaces with the body of the tree, we fill in the latter with curved strokes.

1

2

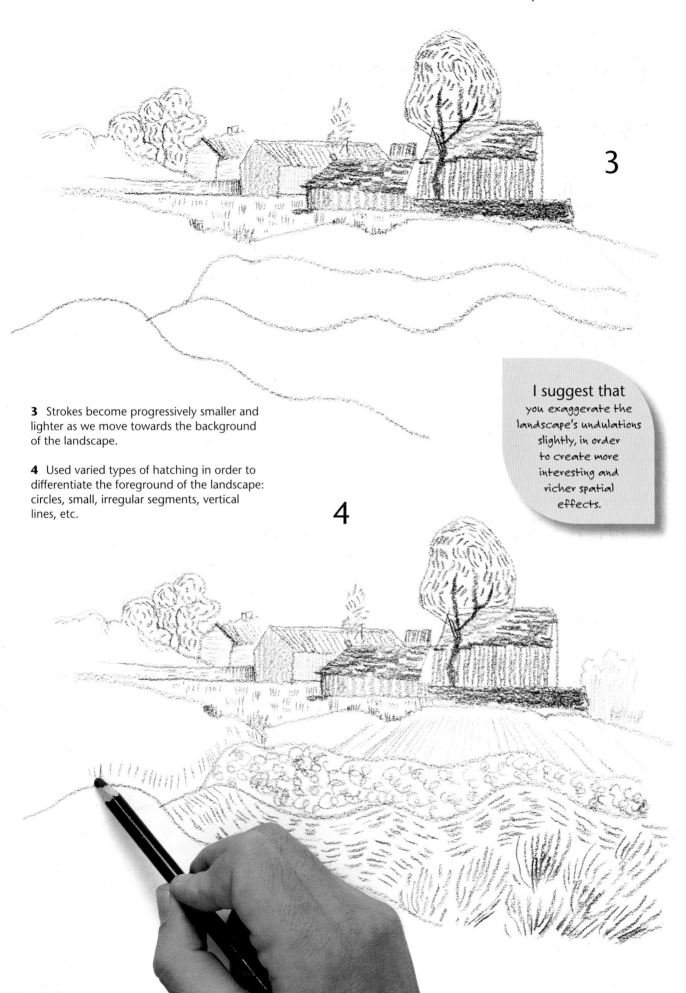

3

3 Strokes become progressively smaller and lighter as we move towards the background of the landscape.

4 Used varied types of hatching in order to differentiate the foreground of the landscape: circles, small, irregular segments, vertical lines, etc.

4

I suggest that you exaggerate the landscape's undulations slightly, in order to create more interesting and richer spatial effects.

Indicating distance

The hatches of the drawing become larger and more intense as we depict the foreground of the landscape. This is the basic element of all landscape drawings: the foreground must be emphasized the most. In the following exercise, that emphasis has been combined with different types of hatches, thereby allowing us to differentiate space and depth of distance.

5

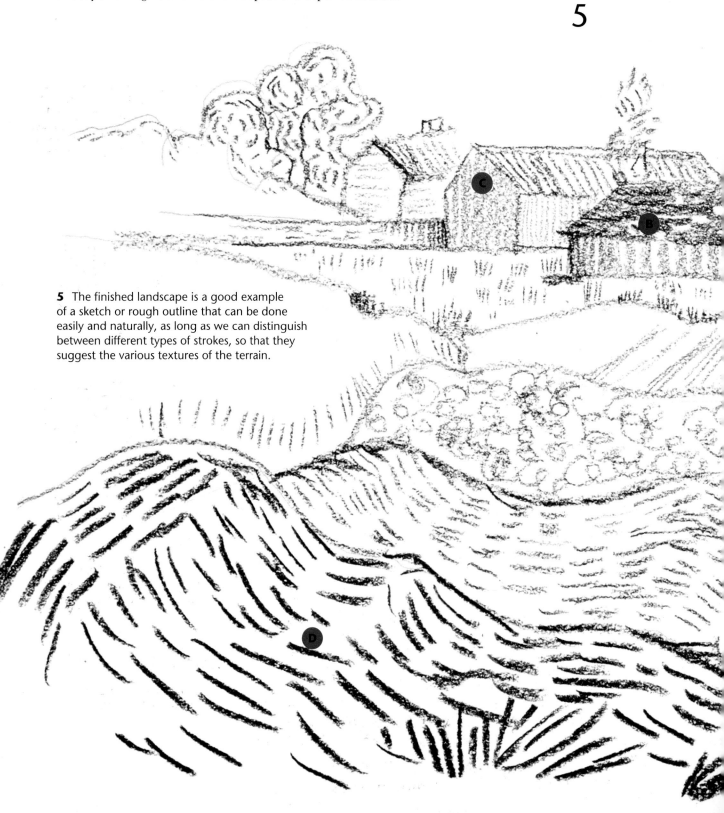

5 The finished landscape is a good example of a sketch or rough outline that can be done easily and naturally, as long as we can distinguish between different types of strokes, so that they suggest the various textures of the terrain.

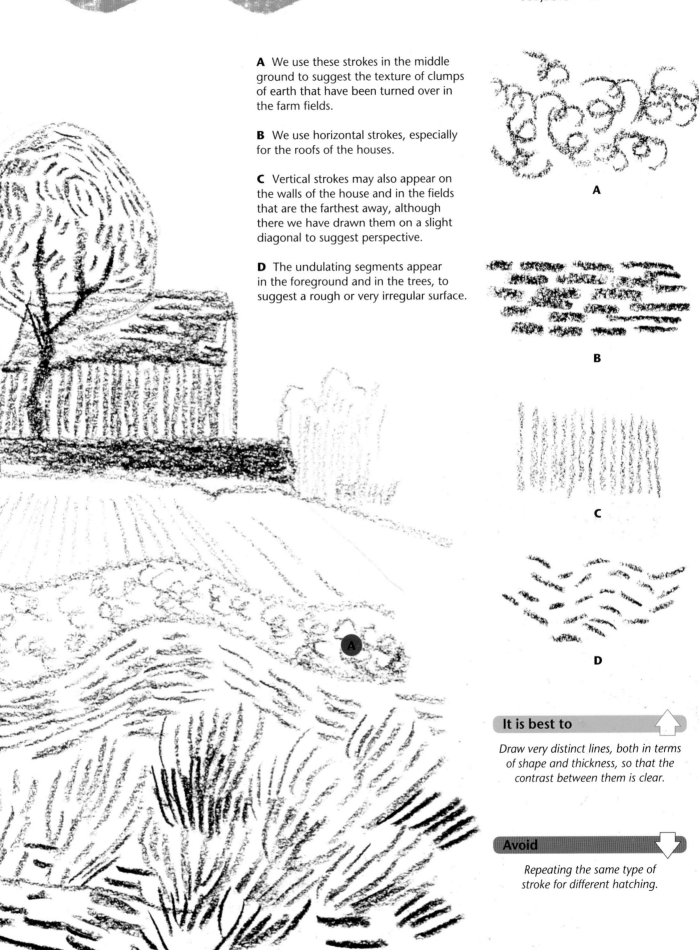

A We use these strokes in the middle ground to suggest the texture of clumps of earth that have been turned over in the farm fields.

B We use horizontal strokes, especially for the roofs of the houses.

C Vertical strokes may also appear on the walls of the house and in the fields that are the farthest away, although there we have drawn them on a slight diagonal to suggest perspective.

D The undulating segments appear in the foreground and in the trees, to suggest a rough or very irregular surface.

A

B

C

D

It is best to

Draw very distinct lines, both in terms of shape and thickness, so that the contrast between them is clear.

Avoid

Repeating the same type of stroke for different hatching.

1

A charcoal pencil can also be used for conventional shading. The process involves rubbing the tip of the pencil on the paper to give even tone to areas, with little or no traces of lines and strokes. Whether there is more or less shading will be determined by the pressure exerted by the tip of the pencil on the paper.

Landscape shaded with charcoal pencil

1 First, let's lightly trace the bare lines of the contours of the basic elements in the drawing: border, trees, and horizon.

2 Now, let's draw the outlines of the border in the plane in the landscape that is farthest away.

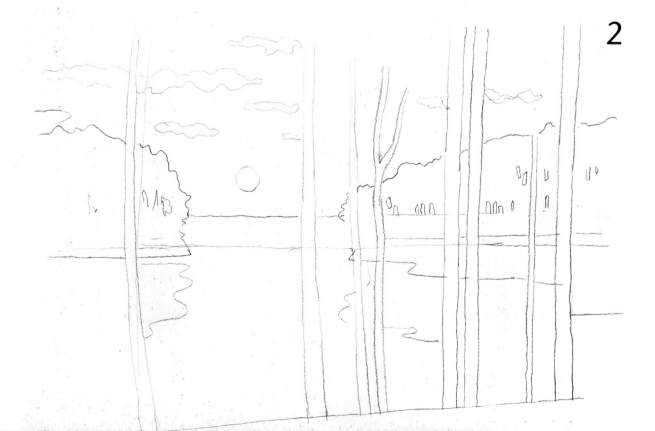

2

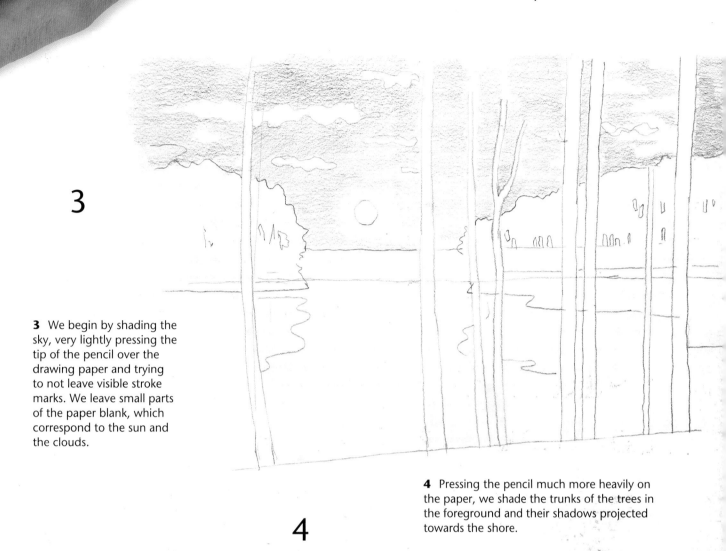

3

3 We begin by shading the sky, very lightly pressing the tip of the pencil over the drawing paper and trying to not leave visible stroke marks. We leave small parts of the paper blank, which correspond to the sun and the clouds.

4 Pressing the pencil much more heavily on the paper, we shade the trunks of the trees in the foreground and their shadows projected towards the shore.

4

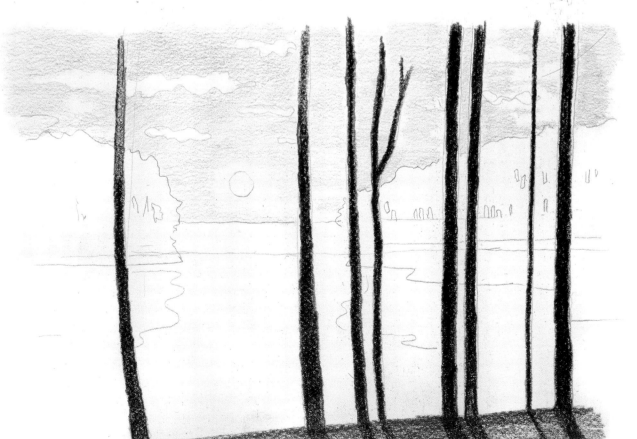

The background of the landscape

The effect of distance in a landscape drawing is always achieved by contrasting the foreground with more distant areas. In this case, that contrast is determined by the large horizontal plane of the lake. This plane has a lighter tone than the foreground, of course, but it is also lighter than the shore in the background, which is of medium intensity. The shadows projected over the lake connect certain areas with others.

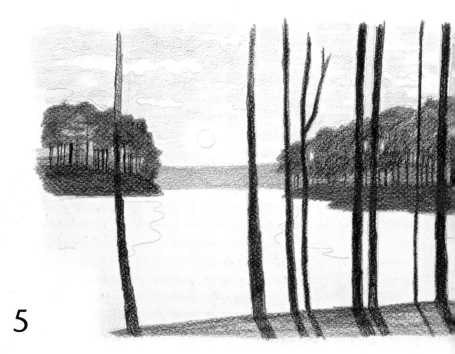

5

5 We shade the tree-lined shore in a uniform tone, not as dark as that of the foreground, highlighting the irregular shape of the tree tops.

6 With a slightly less intense tone than before, we shade the reflection of the trees over the lake, leaving a blank area in the middle to represent the winter sun shining over the water.

6

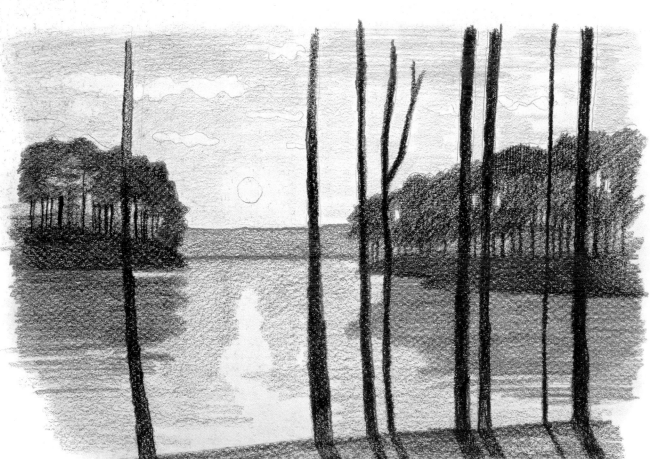

7 Lastly, let's draw the branches and the leaves of the pines in the foreground. Here, we let the strokes of the charcoal pencil remain visible since they help to represent the pine needles.

7

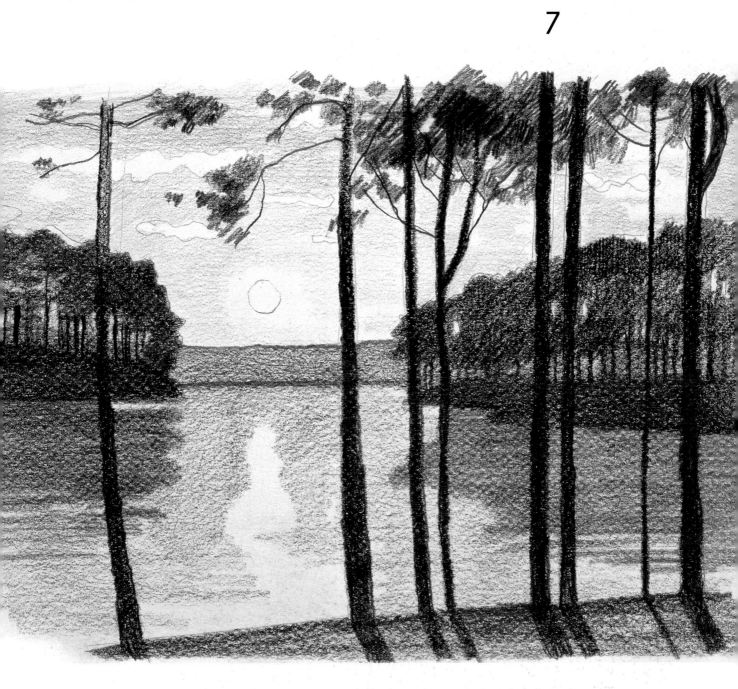

It is best to	Avoid
Really darken the tree trunks in the foreground, so that they contrast against the lighter intensity of the shadows in the background.	*Using intense strokes for shadows in the sky. These should be very light and should barely contrast with the white areas on the paper.*

Still-life crosshatched with charcoal pencil

Crosshatched shading allows complex subjects to be methodically constructed and shaded. This exercise demonstrates the process of creating a drawing that brings together various vegetables in a still-life. The method consists of applying the technique of drawing strokes in charcoal pencil systematically, in order to define and contrast each element so that each one is naturally integrated into the whole.

1 This simple drawing based on a circle, a triangle, and a square allows us to outline and arrange the groups of vegetables on the paper, according to their size and shape.

2 Add the stems and little root ends of each vegetable until all of them are perfectly identifiable.

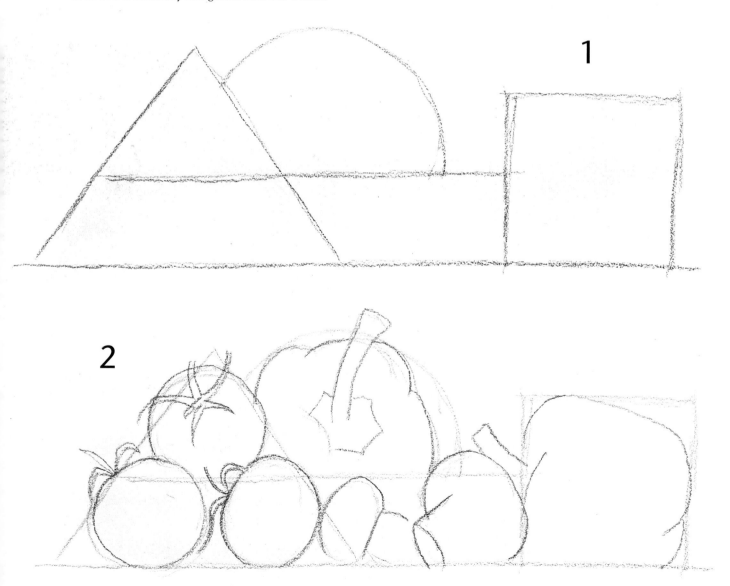

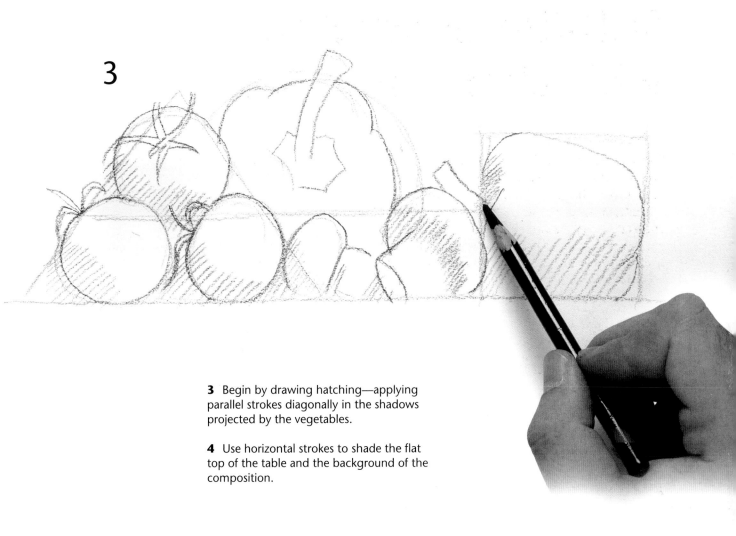

3 Begin by drawing hatching—applying parallel strokes diagonally in the shadows projected by the vegetables.

4 Use horizontal strokes to shade the flat top of the table and the background of the composition.

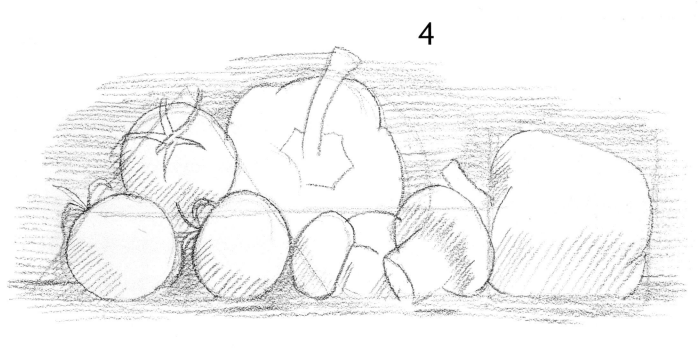

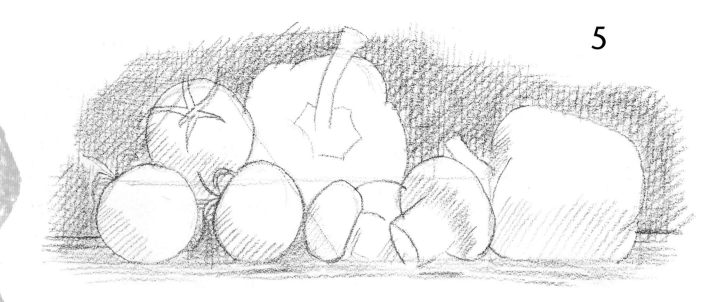

5

Chiaroscuro hatching

The advantage of shading using hatching is that it allows us to gradually intensify the shadows, checking at all times to be sure that the relationship between light and shadow is right and adjusting here and there to get the proper balance. From here, we move on to chiaroscuro, that is, the final contrast that brings together or unites all the contrasts into one complete effect.

5 We crosshatch the background with diagonal strokes to convey an even darker tonality.

I suggest that when first learning to draw, you choose fruits and vegetables (and objects in general) with simple forms, without complicated leaves or highly accentuated relief areas.

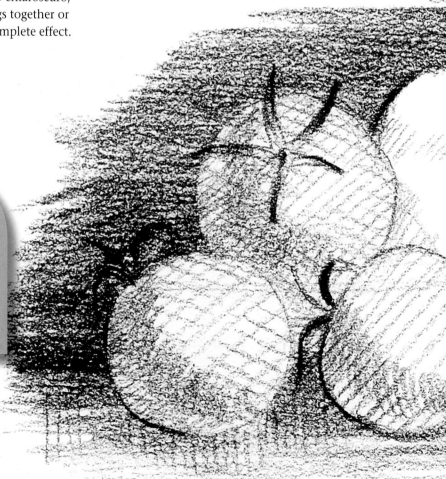

6

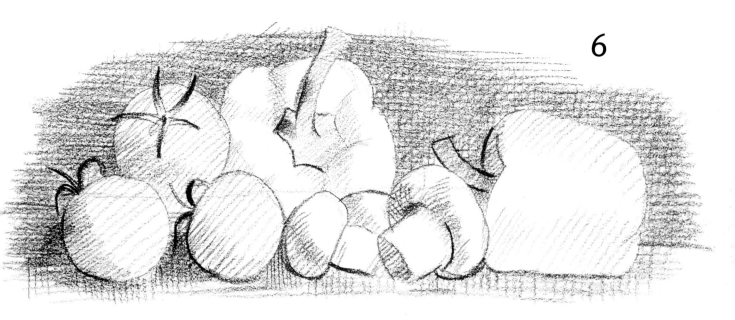

6 Now let's add more crosshatching to the background, this time vertically, to make it even darker. Also, retrace some lines and contours with dark strokes.

7 To complete the drawing, darken the background even more with intense horizontal crosshatching strokes.

7

It is best to

Work systematically with the cross-hatching, drawing first in one direction and then in the other, to cover all the areas which should be shaded.

Avoid

Superimposing different stroke angles on perpendicular or diagonal crosshatched lines.

Rubbing with charcoal sticks

Rubbing is a typical technique for shading with charcoal sticks that consists of spreading and softening charcoal smudges with a rag (if the drawing is very large), smudge stick, or with the fingertips. The result gives a much softer and hazy effect when compared to shading with crosshatching, and allows for progressive transitions from light to shadow. This exercise focuses on shading two curved objects and allows you to appreciate the progressive quality of rubbing with charcoal.

Curved bodies are the ones that are most receptive to shading by rubbing with charcoal. This drawing is made by applying charcoal to produce a rubbing effect with the fingertips. The darker tones are the result of the final applications of charcoal pencil.

A After adjusting the initial drawing, we can draw in the areas intended to appear in darker tones using a charcoal stick.

B Now we spread and rub the charcoal with our fingertips until we achieve a soft transition between light and shadow.

C Once the shape of the objects has been defined by rubbing, let us spread the crosshatching around the objects with a charcoal pencil to create a much darker area that stands in contrast.

D Finally, we rub the crosshatching in charcoal pencil with the fingertips to unify the smudged shadows.

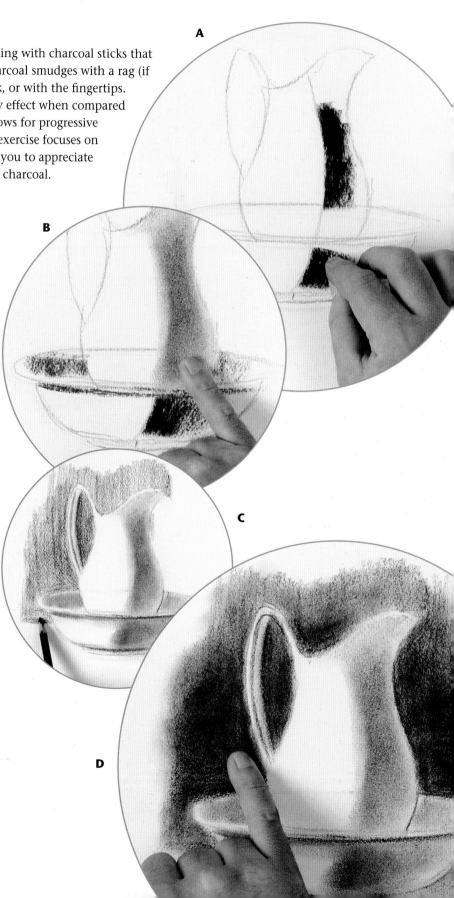

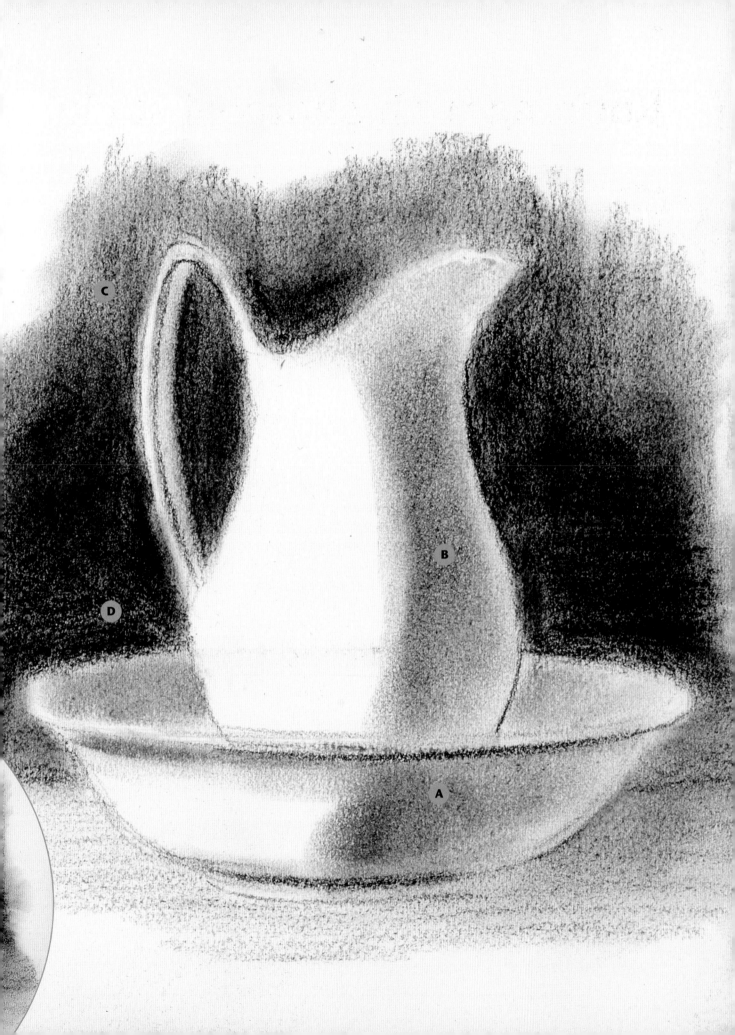

Architecture is a somewhat more difficult subject for beginners, but it illustrates the method for constructing a drawing with charcoal sticks using the rubbing technique. The drawing shows part of a famous Barcelona building by the modernist architect Antoni Gaudí, called Casa Milá: chimneys in fantastic shapes that suggest strange characters. The contrasts and shapes echo one another in space, which becomes deeper and deeper with respect to the foreground.

Architectural forms with charcoal sticks

In this drawing, there a great richness of tonality, most of which is achieved by rubbing. There are also black accents that break up the systematic smudging of the tones. The atmospheric quality of the picture as a whole requires the application of smudging in all areas.

A Create the basic outlines by making some soft lines drawn with the tip of the charcoal.

B Before smudging, we fill in the areas that we want to be darker by rubbing the flat side of the charcoal stick on the paper.

C Next, we smudge the drawing with our fingertips.

D For certain details, we may want to clean the paper with a kneaded eraser in order to restore the original white color.

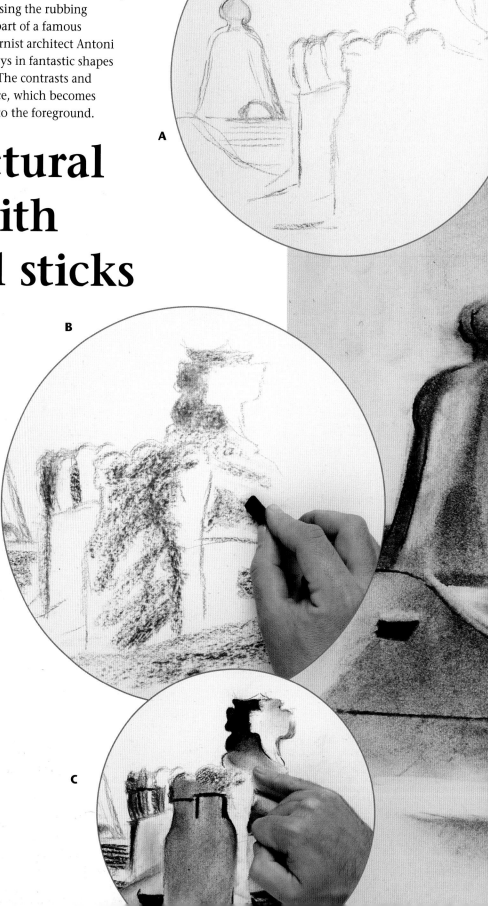

A

B

C

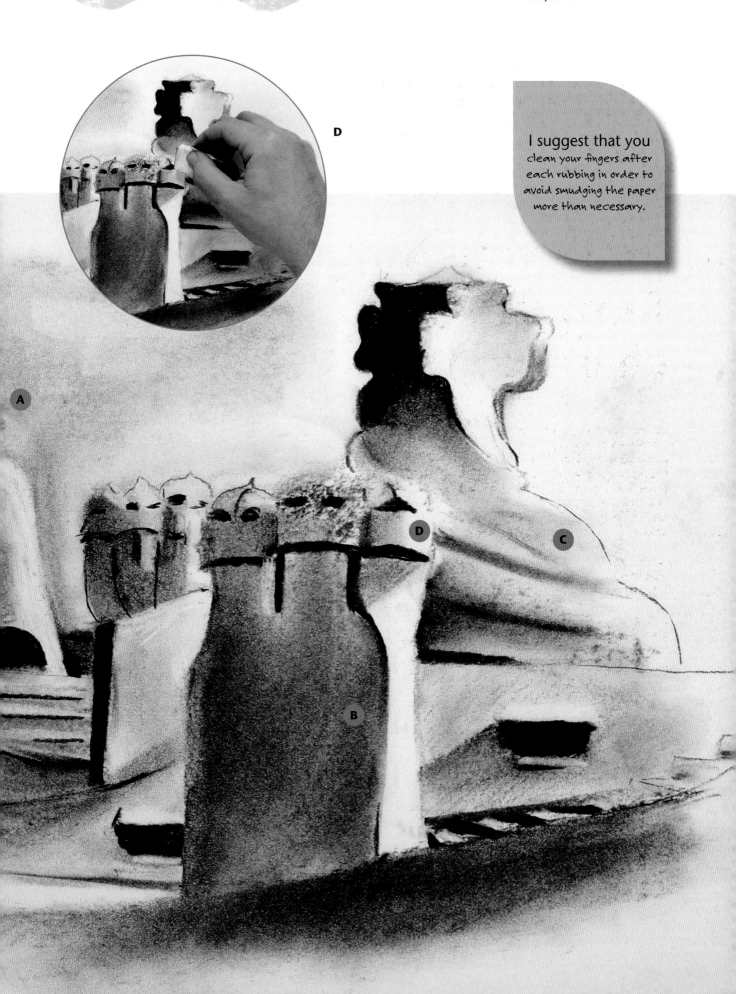

D

I suggest that you clean your fingers after each rubbing in order to avoid smudging the paper more than necessary.

Architectural forms with charcoal sticks

This drawing isolates an element in the previous subject: a ventilation duct in Casa Milá, designed by Antoni Gaudí. The duct's organic form suggests a dragon's head or some other fantastic creature. For the artist, this subject provides the opportunity to practice drawing a picture with rubbing in charcoal. We will use a charcoal stick and a charcoal pencil to fill in the detail work.

1 We won't use a sketch made up of lines, but instead a charcoal block that we will continue to shape like a sculpture, little by little.

2 Next we draw the contours of the piece on the charcoal block, and then lighten the whole area by using the tip of a clean rag.

1

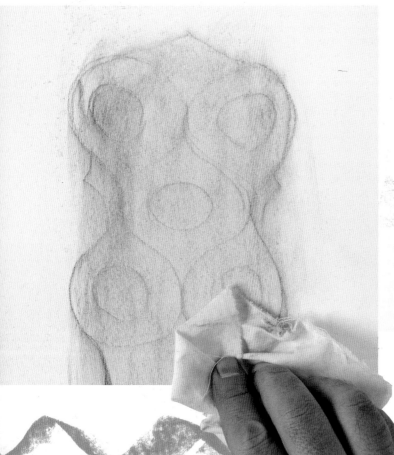

2

3 We sketch a few soft lines to establish the shadows on the side that receives the least amount of light.

3

4 We erase the inside of the openings and retrace the shading with a charcoal pencil. Now, the piece appears much clearer.

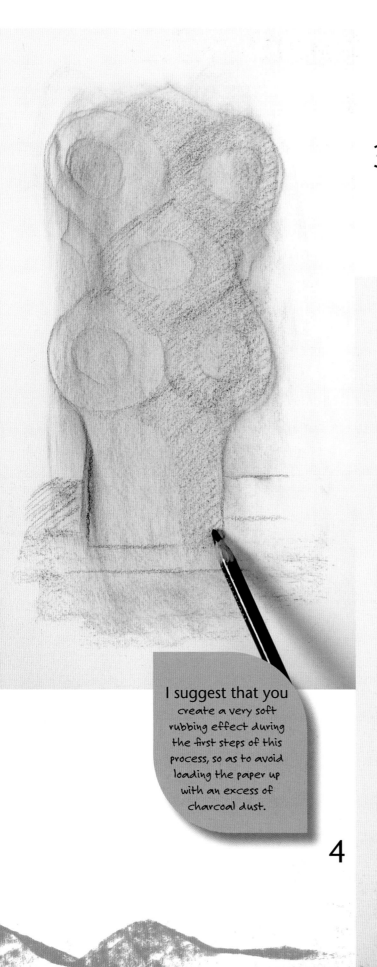

I suggest that you create a very soft rubbing effect during the first steps of this process, so as to avoid loading the paper up with an excess of charcoal dust.

4

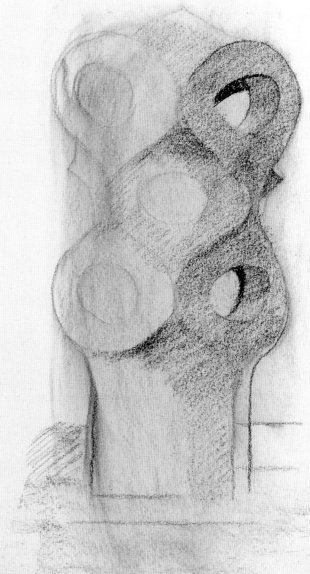

5

Interplay of light and shadow

The continuous undulating shape of this motif makes light and shadows overlap and merge together. This effect softens the edges that we have drawn and separates the changes in tone between different areas.

This work consists of continuing to define each area by shading and rubbing, so that the results appear unified and are rich in tonalities.

5 The undulating edges are the dividing lines that can be used to create contrasts in light and shadow, which are enough to increase the darkness on the inside of these edges.

6 Once the whole piece has been rubbed, erase the outside part so that the contours are clearly defined.

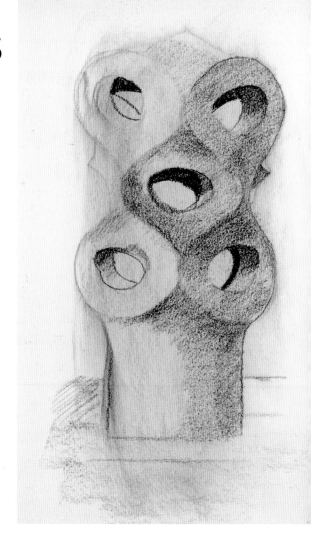

6

It is best to ⬆

Use a charcoal pencil at the end of the process to emphasize the darker aspects.

Avoid ⬇

Drawing outlines with a charcoal stick; it is much more effective to use a charcoal pencil.

7 Darken the base upon which this architectural shape rests, in order to emphasize its presence in the drawing.

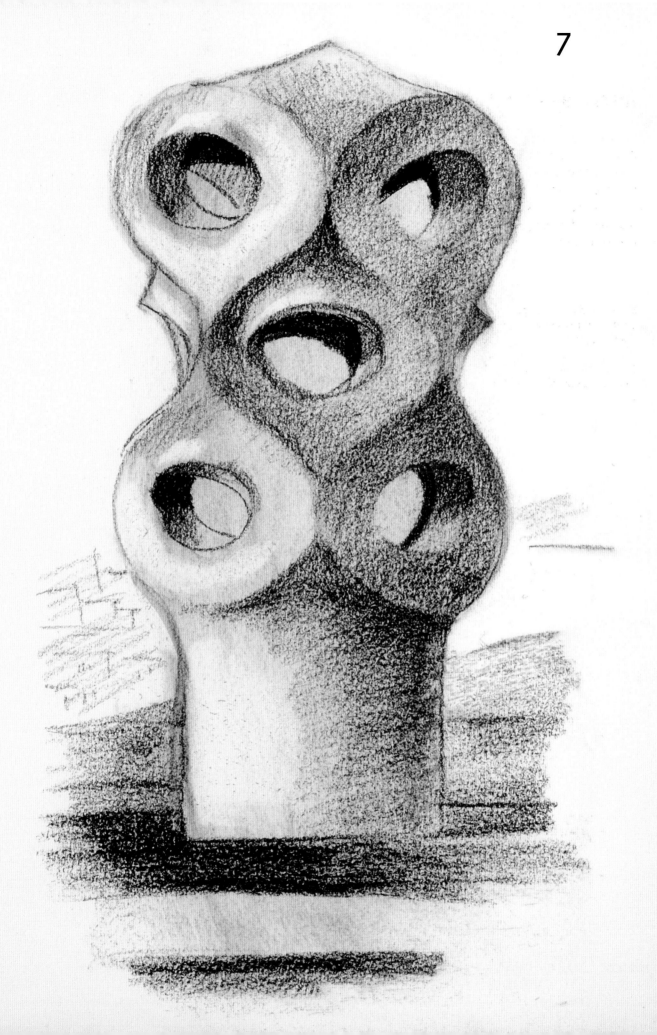

Landscape with nib pen

Drawing with a nib pen requires absolute control of the stroke, but, above all, it requires a sense of freedom. The artist must not be inhibited and must allow for a certain degree of freedom of movement with the wrist. It is best to avoid using too many similar stock patterns, which can lead to rigid results. This landscape reflects a varied and diverse treatment. Here, the straight strokes of the architectural forms contrast with the more sinuous lines of the trees and vegetation.

Here we depict a landscape rich and complex in appearance. The process involves systematically repeating a small number of linear strokes that vary in size and location.

A We apply horizontal or vertical hatching to the walls and roofs.

B We softly trace and barely fill in the trees that receive the most light, using very light and informal strokes.

C We shade the darkest trees with dense hatching made up of short horizontal strokes.

D This intermediate tonality is produced by an accumulation of finely scrawled lines, which fill in the contours of the tree.

E The fir tree is shaded with two symmetrical hatchings that imitate the irregular contours of conifers.

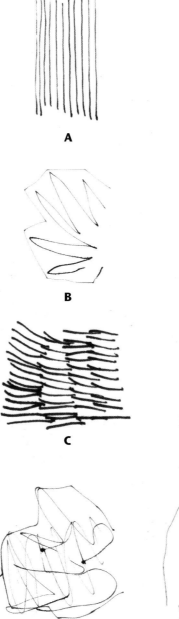

A

B

C

D

E

Here we create a very basic and schematic representation of several roses using a nib pen with blue ink. We systematically apply similar nib pen strokes, producing results that work equally well for the flowers as well as the leaves and stems.

1

Roses with nib pen

1 Two circles and a few straight lines are enough to position the shapes and define their relative size. The initial sketch is done with a pencil.

2 For the top rose, draw arcs of a similar shape and size that close around a central point. It is necessary to maintain a more or less constant separation between each stroke.

2

I suggest that you draw all the petals with a pencil before tracing them with ink in order to ensure that the results are harmonious and consistent.

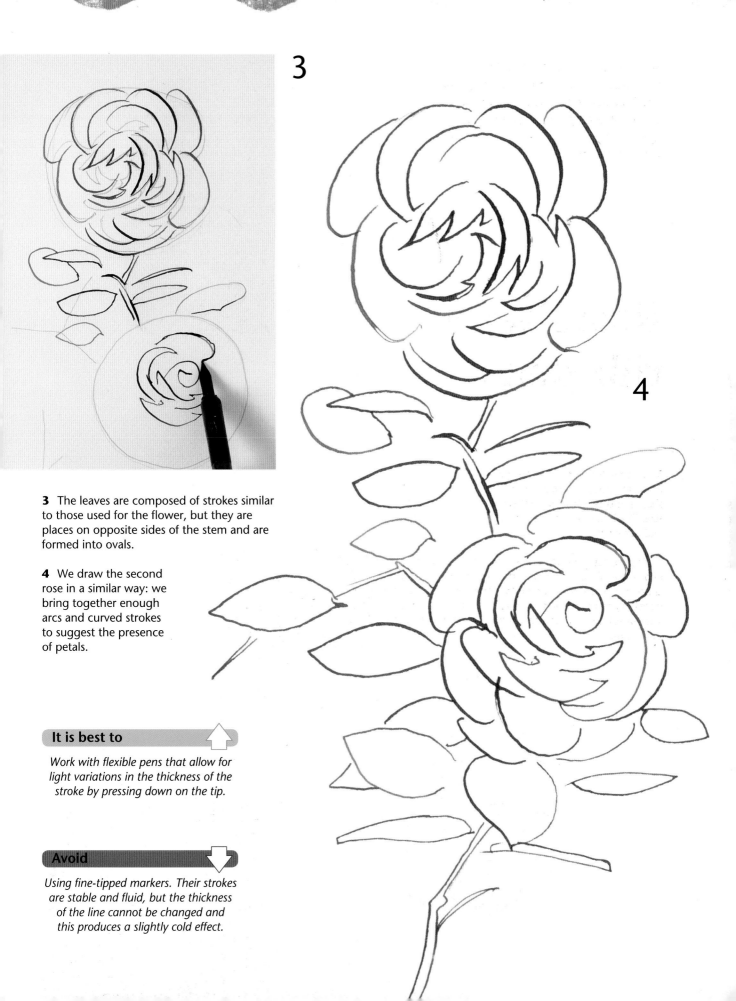

3

4

3 The leaves are composed of strokes similar to those used for the flower, but they are places on opposite sides of the stem and are formed into ovals.

4 We draw the second rose in a similar way: we bring together enough arcs and curved strokes to suggest the presence of petals.

It is best to ⬆

Work with flexible pens that allow for light variations in the thickness of the stroke by pressing down on the tip.

Avoid ⬇

Using fine-tipped markers. Their strokes are stable and fluid, but the thickness of the line cannot be changed and this produces a slightly cold effect.

Plant drawn with bamboo pen

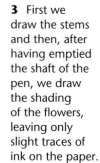

1

A bamboo pen is made from a piece of dried bamboo and finished with a bevel edge; starting at the tip of that edge runs a long shaft through which the ink is dispensed. This instrument allows us to work loosely and spontaneously by using dark, irregular strokes. It does not allow for precise or small details to be added, just lively and resolute strokes. In this exercise, we demonstrate the basic technique for drawing with bamboo pen, applied to drawing a dried plant.

1 We can work with a geometric sketch or without one, since in drawing with bamboo pens the most important thing is spontaneity. The intensity of the stroke depends on the amount of ink loaded in the pen.

2 If we press the bamboo pen firmly, the cut at the point opens and the stroke divides in two, creating an interesting effect for drawing plants.

2

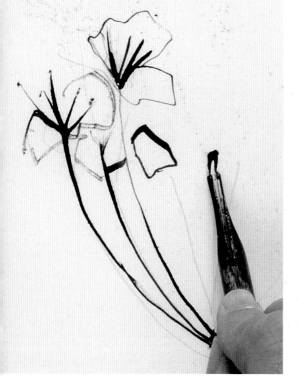

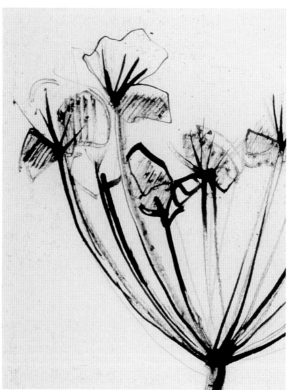

3 First we draw the stems and then, after having emptied the shaft of the pen, we draw the shading of the flowers, leaving only slight traces of ink on the paper.

3

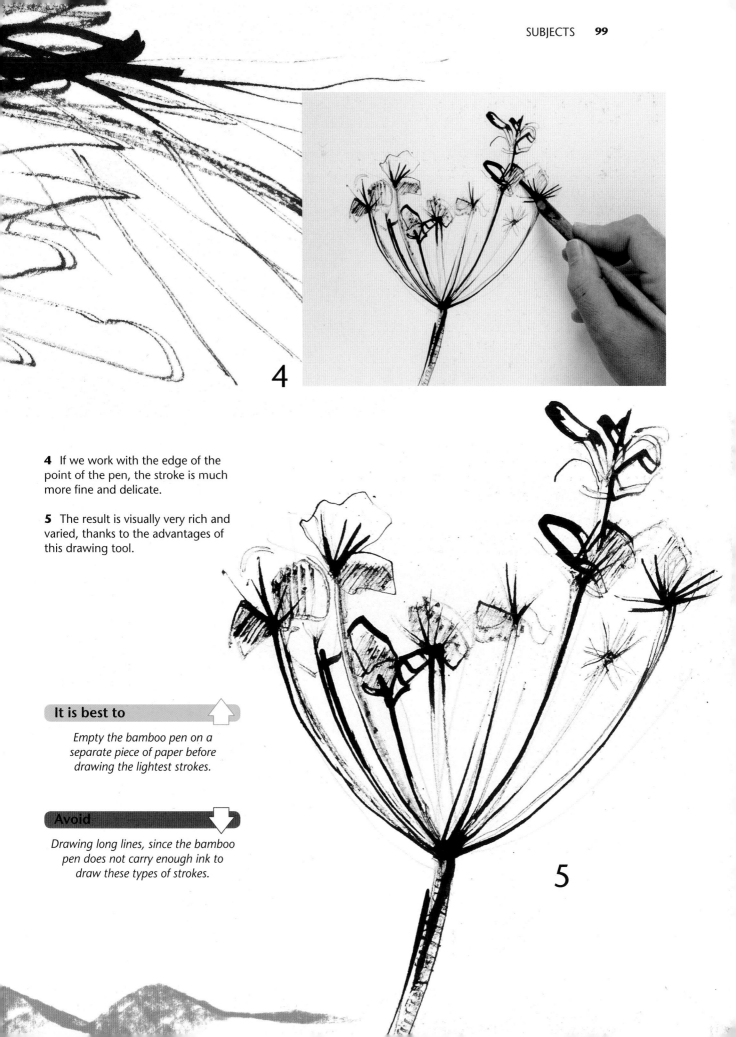

4

4 If we work with the edge of the point of the pen, the stroke is much more fine and delicate.

5 The result is visually very rich and varied, thanks to the advantages of this drawing tool.

It is best to

Empty the bamboo pen on a separate piece of paper before drawing the lightest strokes.

Avoid

Drawing long lines, since the bamboo pen does not carry enough ink to draw these types of strokes.

5

Ink washes are a type of drawing done with a paintbrush, and the method is similar to painting with watercolors. Although the full color spectrum is not used, the results have a tonal richness. We have created this wash in a sepia tone (between grayish-brown and ocher), which allows us to develop a diverse array of tones ranging from dark brown to yellow.

Flowers in ink wash

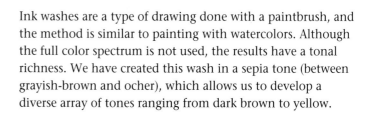

A

Here, the painted areas are just as important as the areas left unpainted: we have left the flowers unpainted, so that their color contrasts with the dark background. We have created the lightest tones in sepia, highly diluted with water. It should also be pointed out that the dark lines are strokes from a nib pen filled with sepia ink.

A The lightest marks are made with sepia ink, highly diluted with water.

B We use undiluted sepia ink in the darkest areas of the ink wash.

B

C To complete the flowers, we spread the wash around the borders, that is, we leave them blank.

D The lines from the nib pen that we have drawn, after extending the wash and allowing it to dry, are visible in different areas in the ink wash.

C

We recommend
that you start the ink wash with a very dark ink; you can always make it lighter later on by adding more water.

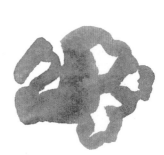

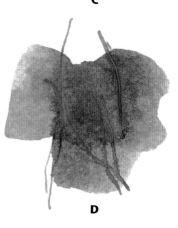

D

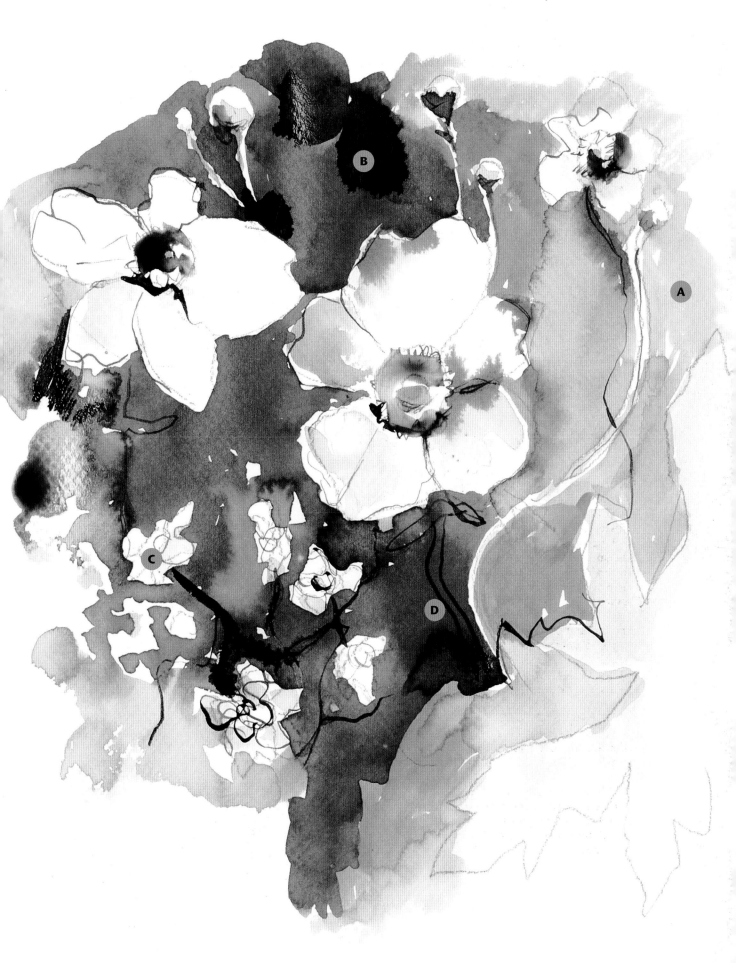

Flowers in ink wash using "resist" technique

The "resist" technique employs a wax crayon to leave specific areas of an ink wash drawing blank and unstained on purpose. We cover the little flowers with strokes from a white wax crayon before placing the wash over them. Finally, at the end, we touch them up with small strokes using a nib pen.

The branch of this almond tree looks like a difficult subject to draw, but it is actually quite simple. We begin by applying strokes with a nib pen, and later placing white wax over the flowers to preserve them. Finally, we cover everything with a generous wash of sepia ink.

A We draw the branch with a nib pen and India ink. We also make small strokes or little points inside each flower.

B One by one, we preserve the flowers by painting them with white wax.

C We spread a wash of sepia ink, slightly diluted in water, over the entire drawing.

D The sepia wash needs to be very dark in order for the flowers to be clearly highlighted against the background and, for this reason, we spread the wash over the drawing without diluting it.

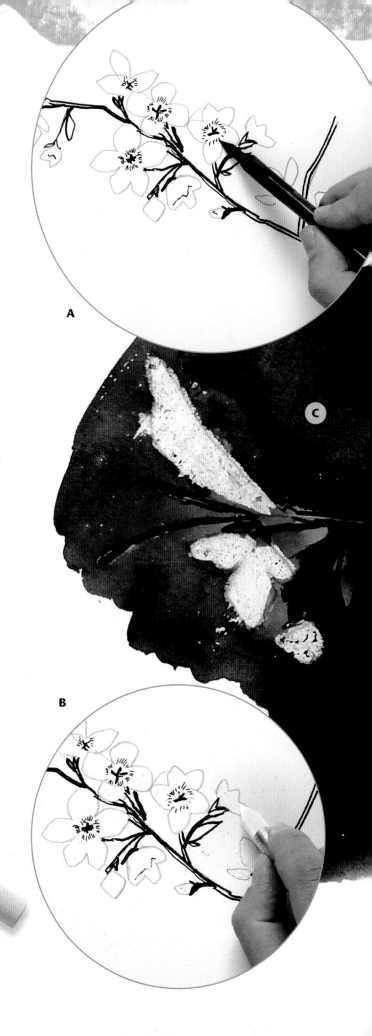

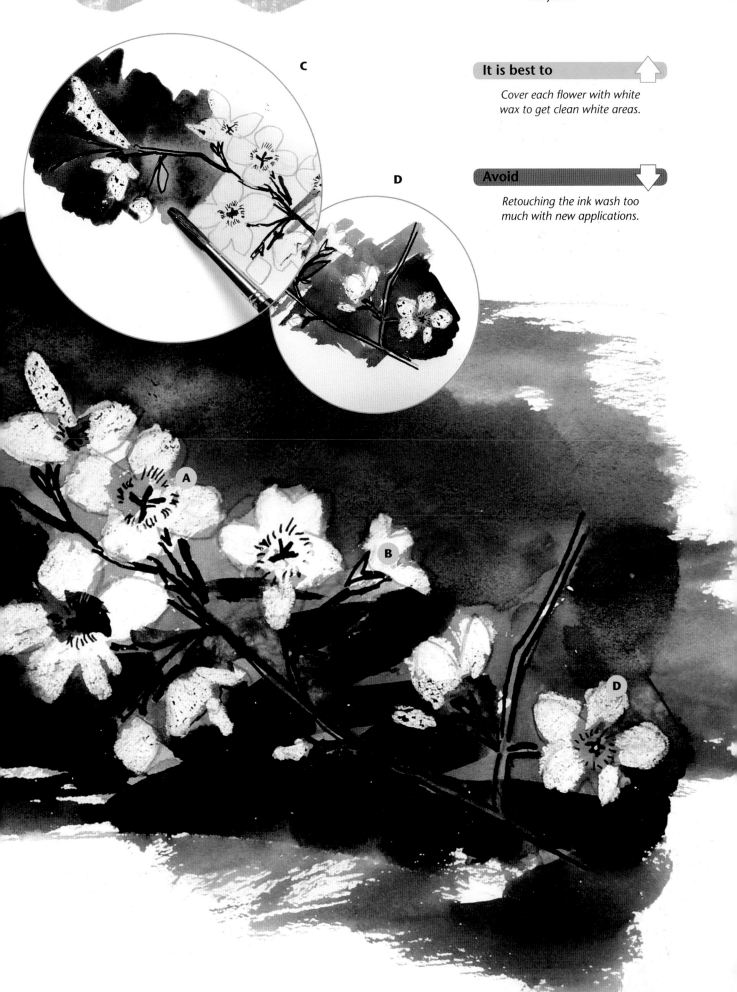

C

D

It is best to

Cover each flower with white wax to get clean white areas.

Avoid

Retouching the ink wash too much with new applications.

Leaves in ink wash

1

Sepia ink wash drawings complement this subject harmoniously: a branch with dried leaves. Sepia matches the natural tone of the leaves exactly. Here, the artist only has to worry about adjusting the different degrees of dilution of the ink in water to achieve different intensities of tone. As a general rule, we advise that before applying a new wash, make sure that the previous washes are completely dry.

1 The initial drawing is just the barest outline of a pattern: just representations of the branches and a leaf in profile appear.

2 We draw each leaf and then cover its surface with washes of different intensities of sepia (diluted with more or less water). There must be both very light washes and very dark washes.

2

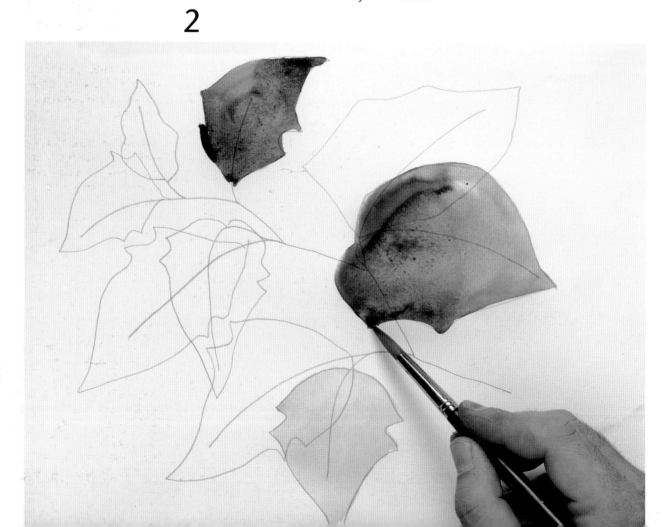

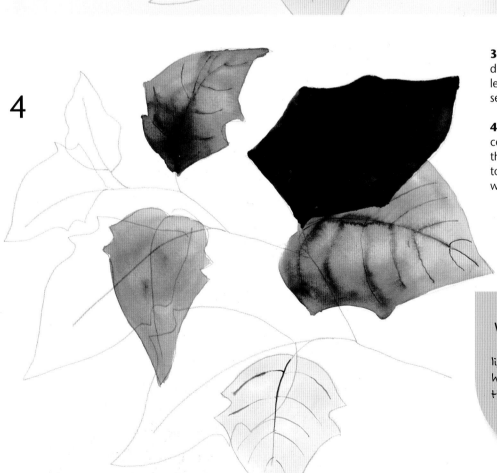

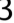

3 As an option, we could draw the fine veins of the leaf with a nib pen and sepia ink.

4 Using undiluted ink, we could retrace over one of the already covered leaves to achieve a very dark wash.

We recommend
starting with the lightest leaves using a highly diluted ink and then finishing with the darker leaves using undiluted ink.

Leaves and stems

The most important thing about an ink wash is that it allows us to simultaneously define shape (the contours) and tonality (the shading). The contours here are the borders of each wash; the shading, on the other hand, comes from the contrasting intensities of each of the washes and the effect produced as a whole. This contrast is what produces the relief and spatial effects in the drawing.

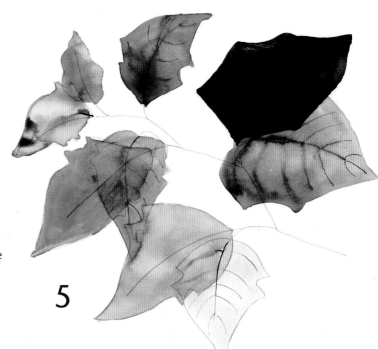

5 Cover all the leaves with a sepia ink wash. Here we see two strokes that are superimposed; the upper stroke has been applied after the lower one has dried.

6 Now let's use the pen loaded with undiluted sepia ink to emphasize the lines of the stems. The lines should be thick at the bottom and delicate at the ends.

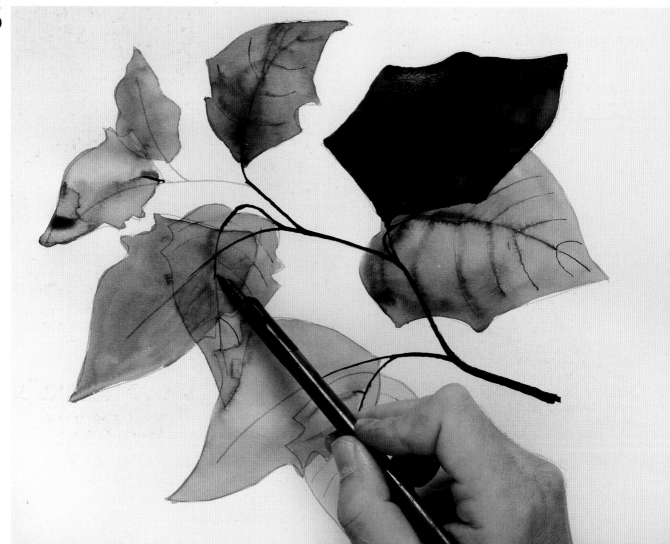

7

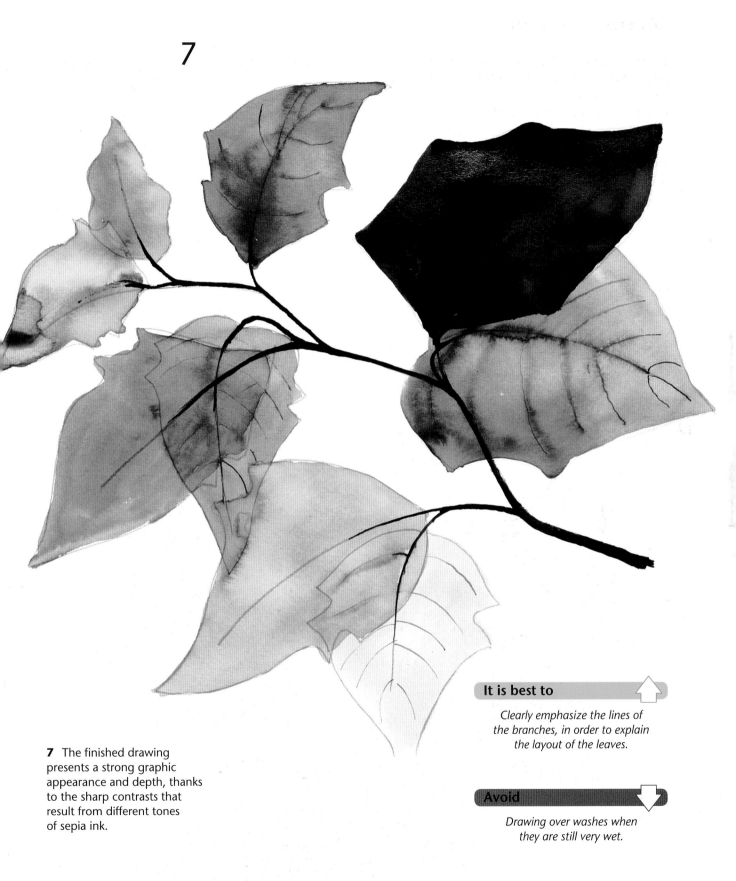

7 The finished drawing presents a strong graphic appearance and depth, thanks to the sharp contrasts that result from different tones of sepia ink.

It is best to ⬆

Clearly emphasize the lines of the branches, in order to explain the layout of the leaves.

Avoid ⬇

Drawing over washes when they are still very wet.

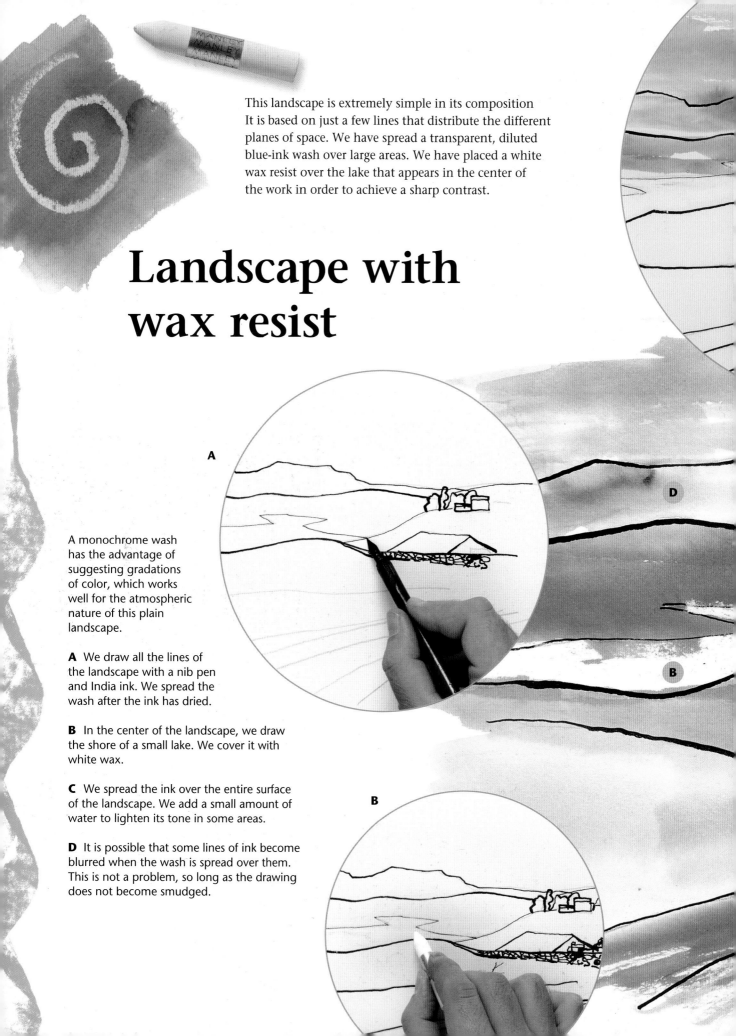

This landscape is extremely simple in its composition
It is based on just a few lines that distribute the different
planes of space. We have spread a transparent, diluted
blue-ink wash over large areas. We have placed a white
wax resist over the lake that appears in the center of
the work in order to achieve a sharp contrast.

Landscape with wax resist

A monochrome wash
has the advantage of
suggesting gradations
of color, which works
well for the atmospheric
nature of this plain
landscape.

A We draw all the lines of
the landscape with a nib pen
and India ink. We spread the
wash after the ink has dried.

B In the center of the landscape, we draw
the shore of a small lake. We cover it with
white wax.

C We spread the ink over the entire surface
of the landscape. We add a small amount of
water to lighten its tone in some areas.

D It is possible that some lines of ink become
blurred when the wash is spread over them.
This is not a problem, so long as the drawing
does not become smudged.

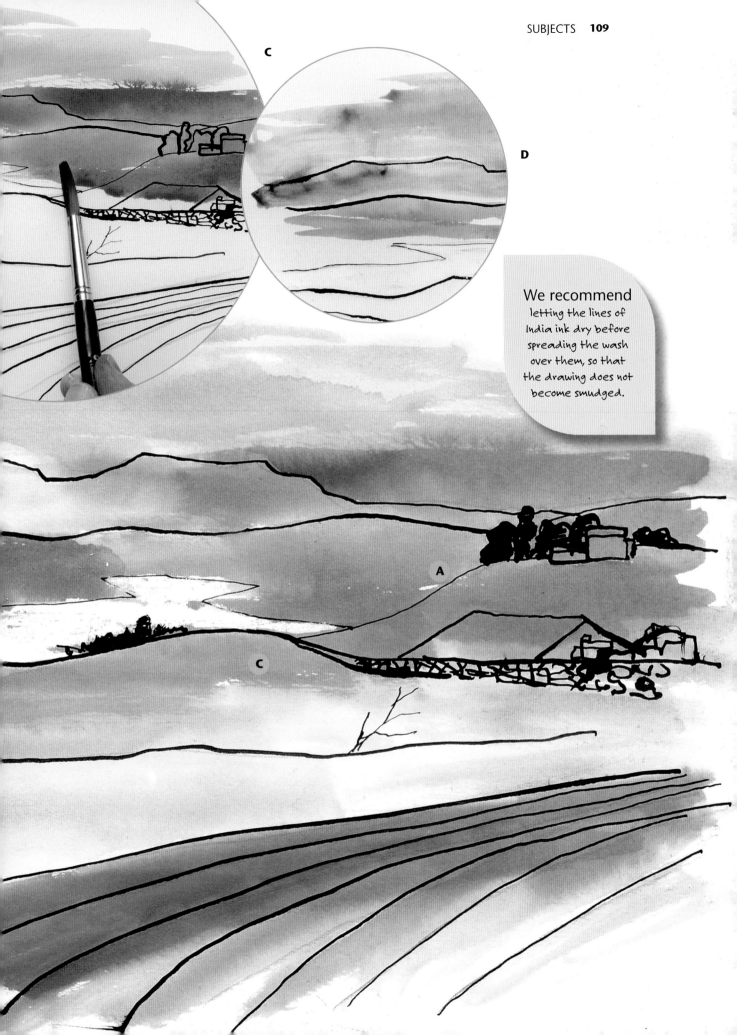

C

D

We recommend
letting the lines of
India ink dry before
spreading the wash
over them, so that
the drawing does not
become smudged.

A

C

Landscape in sepia wash

1

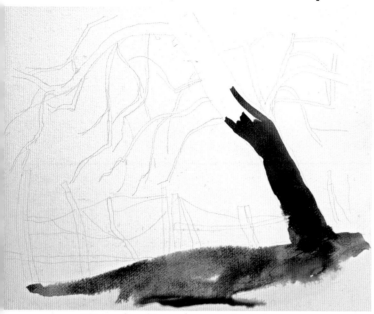

Landscapes are the most appropriate subject for wash drawings. The wash provides atmospheric effects, depth, and unexpected contrasts in a natural way. We have used sepia wash here for an evocative subject: a cloudy day in which clouds are highlighted in silhouette against a very light background. Silhouettes of different tones are created by dissolving ink in a greater or lesser amount of water.

1 First, we create a detailed drawing of all elements of the subject in pencil, without any shadows or crosshatching.

2 After spreading a slightly diluted wash over the trunk, we apply undiluted ink on the branches.

2

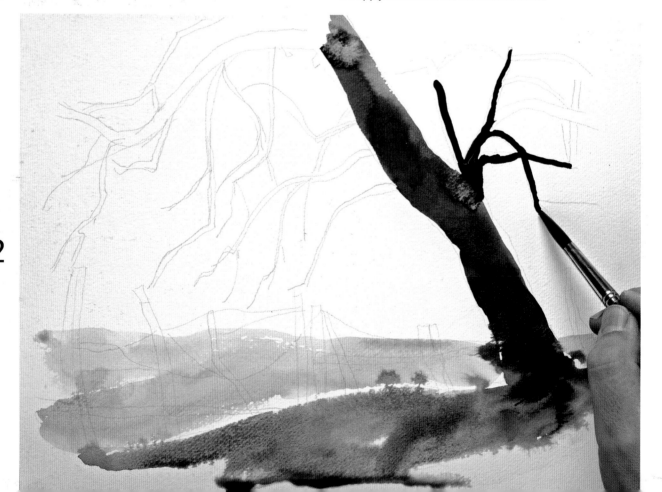

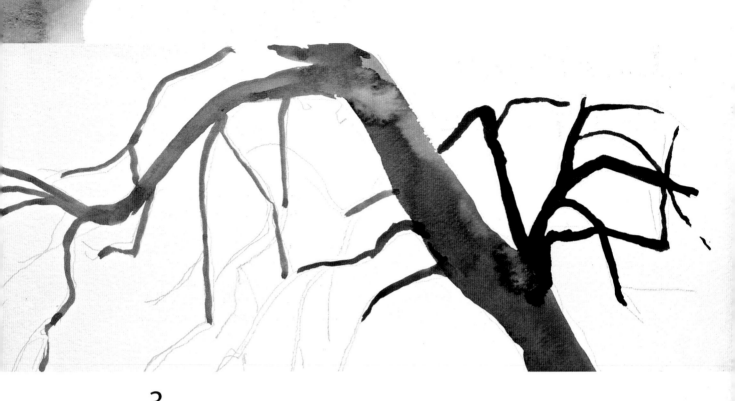

3

3 The darker branches contrast with the rest of the trunk. In this way, a more lively and energetic effect is achieved than if we had applied a single tone of sepia.

4 We spread a very diluted wash in the background and, above it, some dark paintbrush strokes representing fence posts. One of those posts has become blurred when entering into contact with the stain in the background.

4

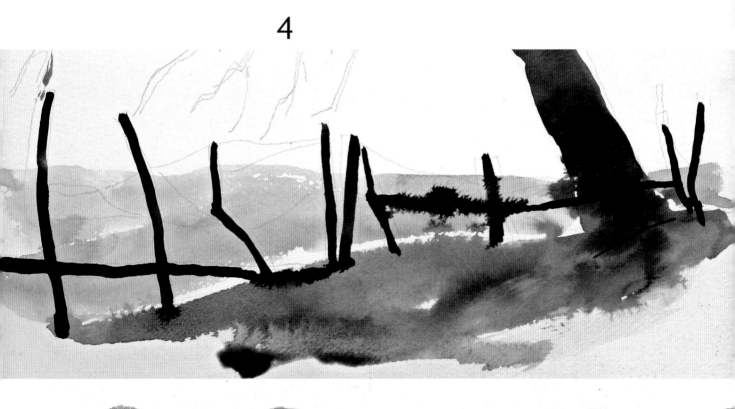

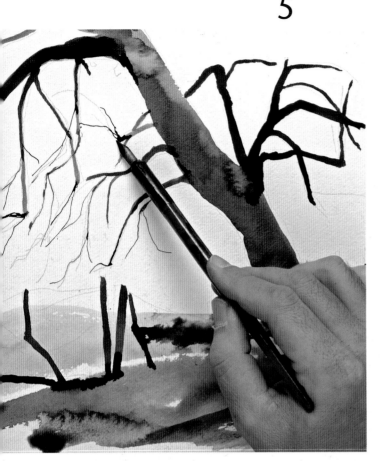

Details and highlighting using a nib pen

Nib pens are a good tool for ink washes. The shapeless nature of washes sometimes requires a linear contrast to give firmness and consistency to the contours of the drawing or to certain details, which would otherwise get lost in the drawing as a whole.

Strokes with a nib pen are drawn by always using undiluted ink and making sure that the washes over which they are applied are almost, but not completely, dry.

5 To draw the thinnest branches of the tree, as well as the leaves, we fill the nib pen with undiluted sepia ink.

6 The leaves are important. We draw them using small stains that are slightly different in size and shape from each other. It is best not to use crosshatching, as it would not complement the thick stains of the drawing well.

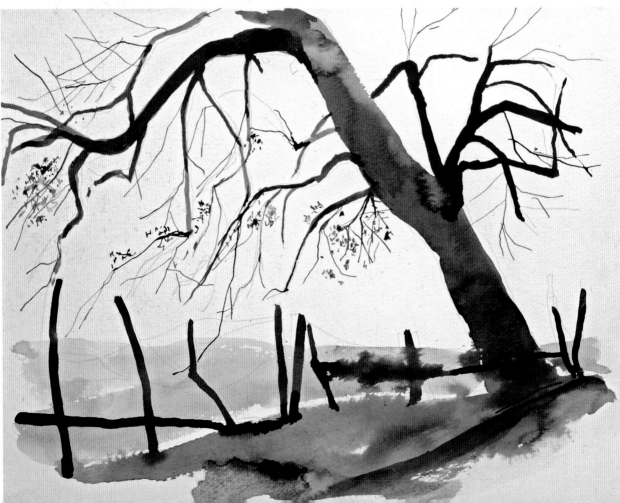

7 Other important details created with the pen include the barbed wire and the outline of some posts that had blurred while the ink wash was being applied.

7

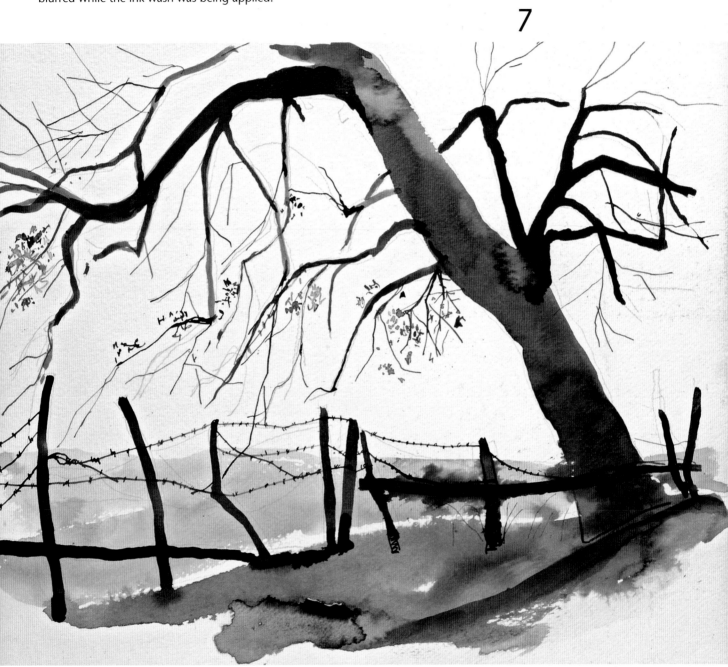

<table>
<tr><td>**It is best to**</td><td>**Avoid**</td></tr>
<tr><td>*Reinforce the contrast between tones because that is the only way to create a sensation of depth.*</td><td>*Letting the washes dry completely before continuing to draw; they should be almost, but not completely, dry.*</td></tr>
</table>

Figure drawing

This book does not attempt to cover all the subjects or techniques of drawing. However, it would not be complete if we did not spend some time on drawing the human body. The following pages contain a few simple step-by-step exercises to help you learn the basics of figure drawing. We suggest that you practice each exercise several times to become familiar with the basic shapes and gain an understanding of the proportions of the human body.

 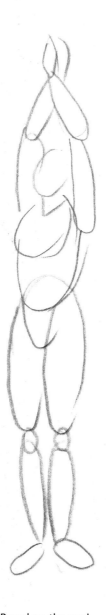 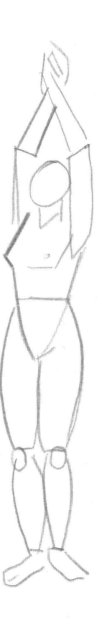 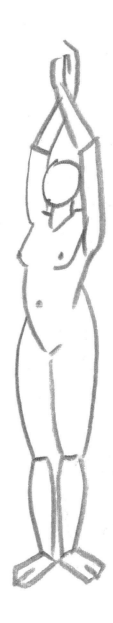

1 With arms lifted up, the arms, torso, and legs have similar dimensions—three overlapping ovals.

2 Based on the oval sketch, we can construct the figure by dividing the previous ovals into smaller ones, which now represent the arms, forearms, legs, calves, and joints.

3 We smoothed and connected the ovals with angular strokes; the sketch looks closer to the normal appearance of a drawing of the body.

4 Here we have further adjusted the curves and lines and added a few small details.

At right, a more finished sketch; we have simply applied some of the principles of shading and highlighting discussed earlier in the book.

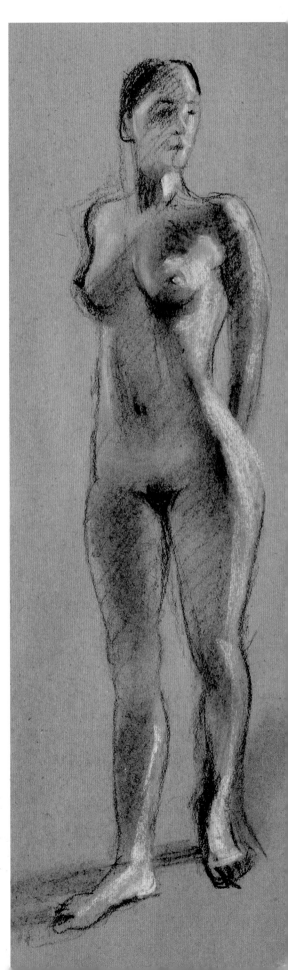

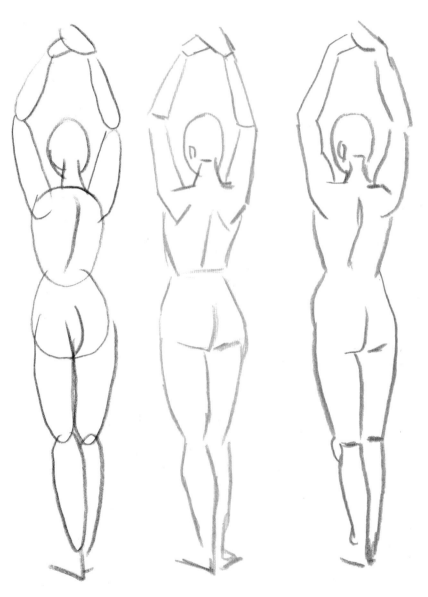

The procedure for drawing the frontal view of the body also applies to the back, with the difference that the torso here is leaning inward, whereas from the front, it leans outward.

This exercise consists of fleshing out the sketches of standing figures shown on the previous pages. Keep in mind while sketching that your lines should not be too overly rigid or tight; try loose, gestural strokes. Again, practice this exercise several times, and try to keep in mind that the outlines of the shapes you are drawing are actually three-dimensional volumes in space.

Frontal figure

1 This sketch is the most important part of the exercise. We work with ovals and trapezoids: For the upper half of the figure, we use trapezoids for the arms and forearms, as well as for the torso of the body. For the legs and the head, let's draw ovals.

I suggest that you practice this generic sketch of a figure before starting to shade it in. Often the sketch produces a sufficient drawing in and of itself.

1

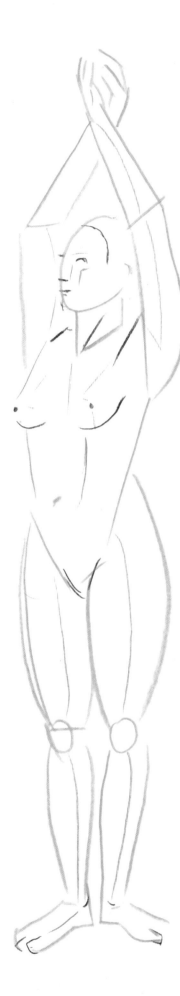

2 Add facial traits and some lines to depict an ideal boundary between light and shadow.

2

> ### It is best to ⬆
>
> *Practice this drawing technique on figures in various positions, using photographs from magazines and newspapers for reference.*

> ### Avoid ⬇
>
> *Drawing by using very short or tentative strokes. It is better to make "big" mistakes, which can be fixed later on, than to accumulate lots of little mistakes that are hard to find.*

3

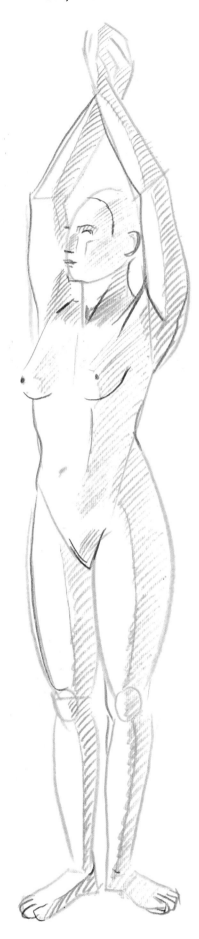

3 Taking the lines which mark the shadows as a standard, we apply hatchmarks in the shaded areas of the figure.

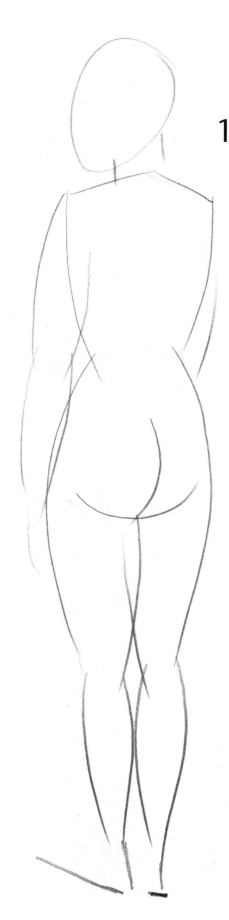

1

Figure seen from the back

This is the counterpart of the previous figure, but in this case, the figure's arms are hanging at its side. We work with oval and pyramid shapes. The lines of the back —the curve of the spine and the shoulder blades— are important to consider. The elbow and knees joints are also key. Once again, we encourage you to copy this sketch and those on the next few pages and practice your own versions of the human form over and over again.

1 This sketch is entirely composed of ovals (including the torso, which is a half oval), connected together at the joints.

2 We add the important lines that depict the elbows, the shoulder blades, the spinal column, the glutes, the back of the leg, and the ankles.

3 The shaded areas occupy about half the space of the arms and legs and the entire back.

It is best to	Avoid
Not to be overly scrupulous about the shaded areas. The shaded hatchmarks should blur the contour lines.	*Closing the lines without leaving any open spaces. These spaces are what give life to the figure.*

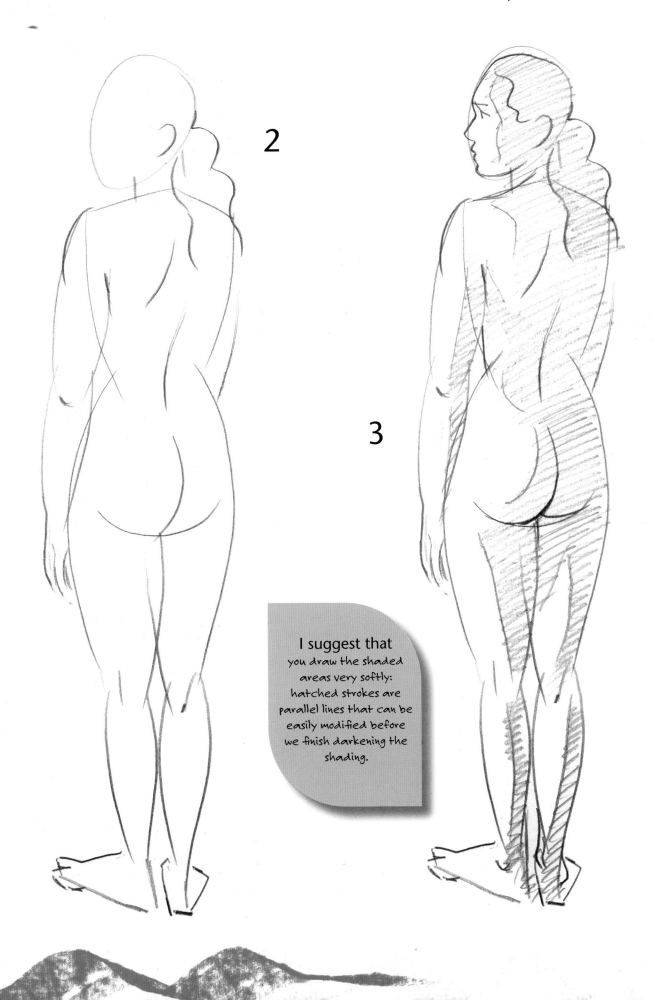

2

3

I suggest that you draw the shaded areas very softly: hatched strokes are parallel lines that can be easily modified before we finish darkening the shading.

Figure in profile

The interesting thing about drawing a figure (whether a nude or not) is the impression of movement that is suggested. The pose represented in this exercise is a clear example of this. The dynamism of the pose is emphasized by the graphic treatment that makes the figure transparent and allows us to see all the contours of the body. Remember that this figure is composed of ovals that intersect, more or less, with other ovals. Thanks to the initial simplicity of these lines, we can achieve a sensation of movement.

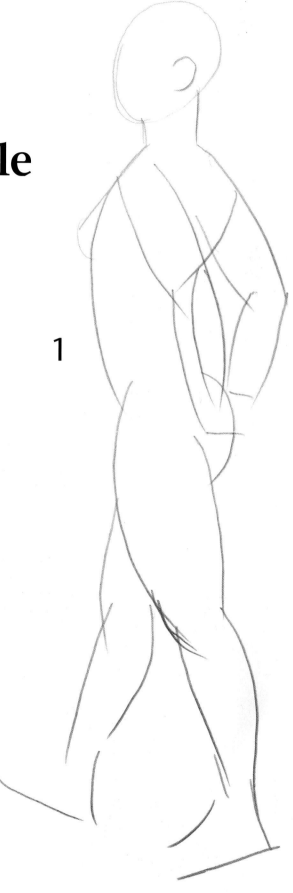

1

1 The key factor here is the pronounced bending of the trunk backwards: a simple curve that goes from the base of the neck to the thigh and another curve parallel in the back.

2 We add lines to depict the face and knees, and we show the dividing lines that separate light from shadow.

3 We illustrate the areas of the body n shadow using simple diagonal hatchmarks.

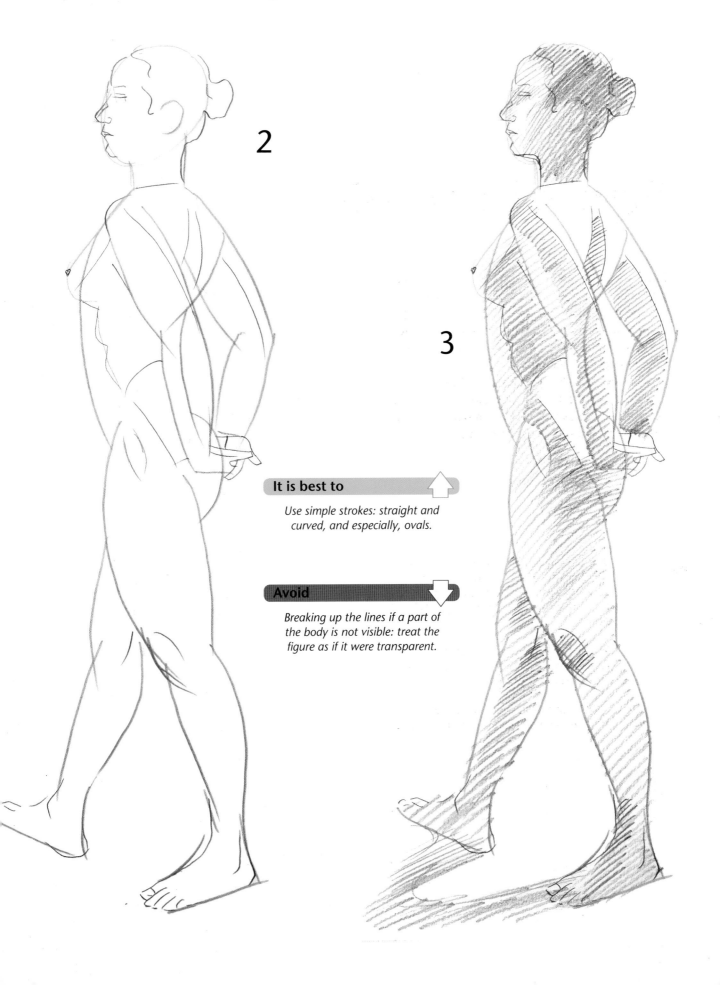

2

3

It is best to

Use simple strokes: straight and curved, and especially, ovals.

Avoid

Breaking up the lines if a part of the body is not visible: treat the figure as if it were transparent.

1

Reclining figure

The question of movement must be applied to all types of poses, including those that show figures at rest.

Movement is presented here in the dynamism of the lines: the contrast and counterpoint between curves and straight lines is responsible for this dynamism. It is crucial to emphasize the fact that all of the figure drawings shown in this section are based on a particular arrangement of ovals that we then can adjust until we feel that they express movement and convey the feeling of the pose.

1 The most critical part is the back, which breaks up the continuity of the oval forms. For the other parts of the body we use interlocking curved lines.

2 We add dividing lines that separate light from shadow before proceeding to darken the parts that are less well lit.

3 As before, we also use hatchmarks for shading and to give relief and volume to the figure.

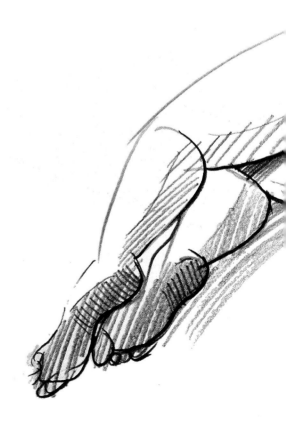

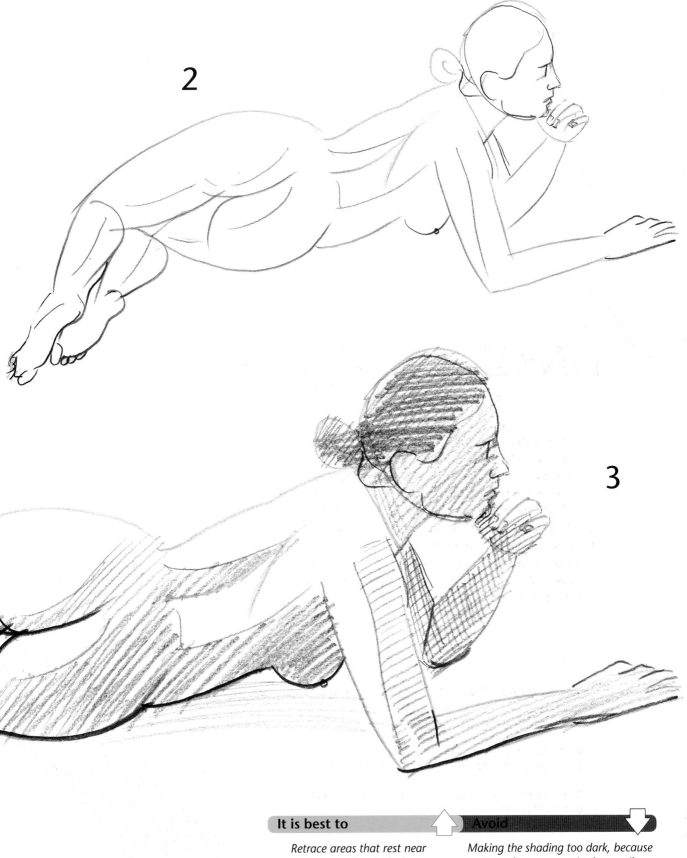

2

3

It is best to	Avoid
Retrace areas that rest near the ground with thicker lines. In this case, the whole right side of the figure.	Making the shading too dark, because it can become a stain that spoils the overall effect of the drawing.

Sketching with sanguine

In the following exercise we draw a man wearing a hat drinking coffee, using sanguine on bluish-gray paper to highlight the warm tonal quality of sanguine. The steps in the sketch are very simple, similar to those used on the previous pages. To help you recreate this sketch, let us construct the figure with simple lines and then shade them in with dense hatchmarks to add relief and volume.

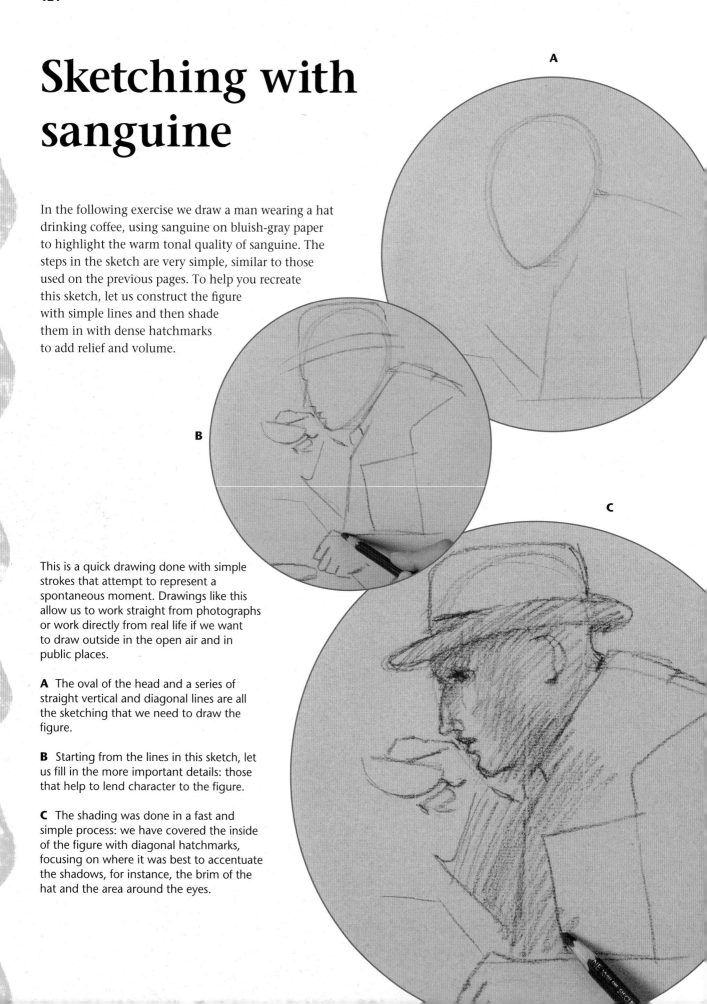

This is a quick drawing done with simple strokes that attempt to represent a spontaneous moment. Drawings like this allow us to work straight from photographs or work directly from real life if we want to draw outside in the open air and in public places.

A The oval of the head and a series of straight vertical and diagonal lines are all the sketching that we need to draw the figure.

B Starting from the lines in this sketch, let us fill in the more important details: those that help to lend character to the figure.

C The shading was done in a fast and simple process: we have covered the inside of the figure with diagonal hatchmarks, focusing on where it was best to accentuate the shadows, for instance, the brim of the hat and the area around the eyes.

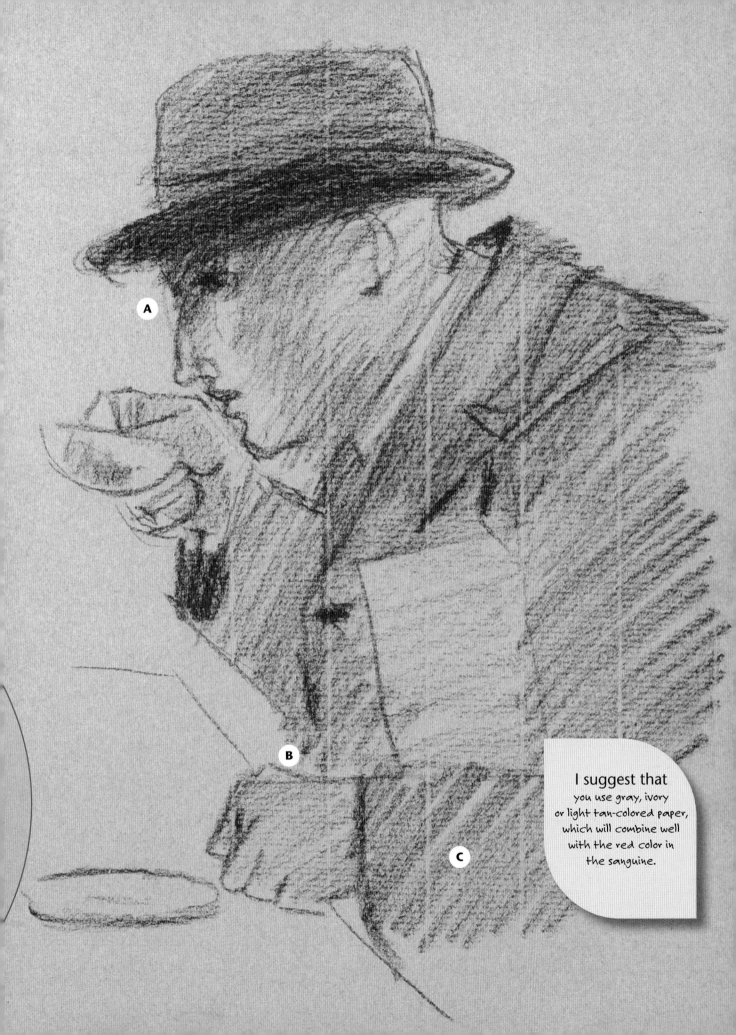

I suggest that you use gray, ivory or light tan-colored paper, which will combine well with the red color in the sanguine.

Nude with sanguine

For this last example, let's draw a female nude with sanguine. Instead of shading and adding tone with hatchmarks, here we are rubbing with sanguine, which gives the figure a soft sensuality. This way of working is typical of drawing with sanguine and produces a result that is especially appropriate for nudes.

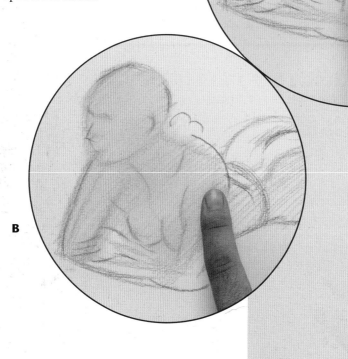

A

B

Even though there are still traces of shaded lines, we see that the shading is softened by rubbing. This conveys a certain softness and fits in well with the nature of the subject.

A Once the sketch is drawn, we apply very gentle shading generally to the whole figure. Allow the tip of the sanguine to slide across the paper without pressing on it.

B Next we rub a fingertip on the shading and smudge the strokes until achieving an overall tone.

C Now we erase areas that are exposed to the most direct light, and we exert more pressure with sanguine to emphasize the areas that need darker tones.

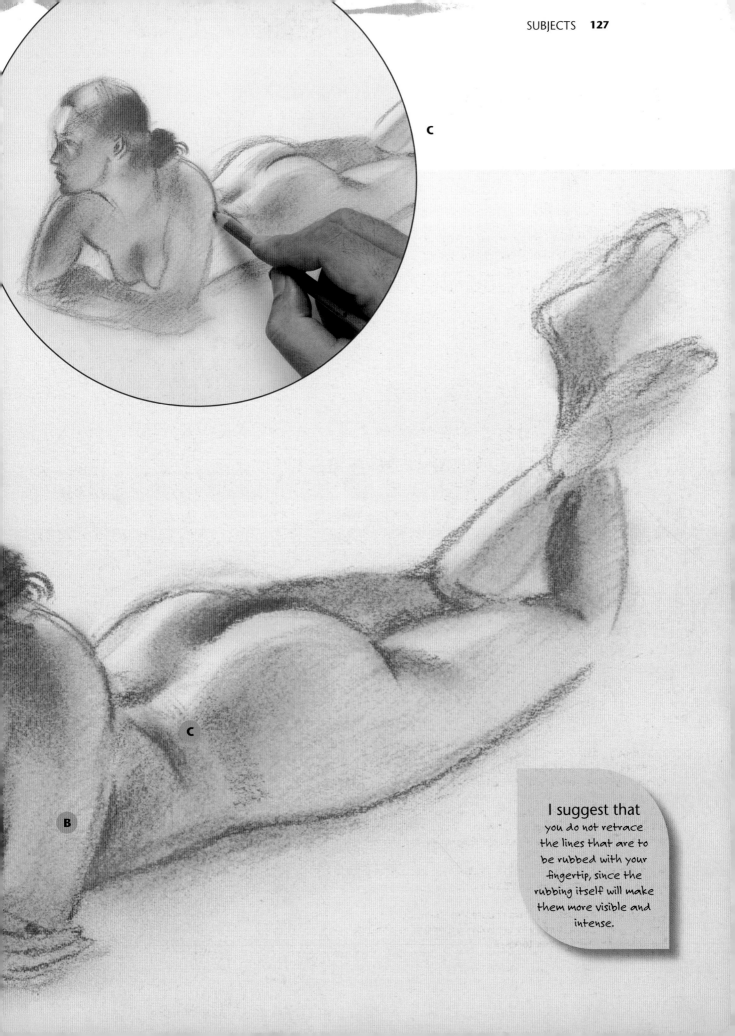

I suggest that you do not retrace the lines that are to be rubbed with your fingertip, since the rubbing itself will make them more visible and intense.

STERLING
New York

An Imprint of Sterling Publishing
387 Park Avenue South
New York, NY 10016

ISBN 978-1-4549-1116-6

Distributed in Canada by Sterling Publishing
c/o Canadian Manda Group, 165 Dufferin Street
Toronto, Ontario, Canada M6K 3H6
Distributed in the United Kingdom by GMC Distribution Services
Castle Place, 166 High Street, Lewes, East Sussex, England BN7 1XU
Distributed in Australia by Capricorn Link (Australia) Pty. Ltd.
P.O. Box 704, Windsor, NSW 2756, Australia

For information about custom editions, special sales,
and premium and corporate purchases,
please contact Sterling Special Sales at 800-805-5489
or specialsales@sterlingpublishing.com.

Manufactured in China

2 4 6 8 10 9 7 5 3 1

www.sterlingpublishing.com